HISTORIC ADVENTURES
on the
COLORADO PLATEAU

HISTORIC ADVENTURES
on the
COLORADO
PLATEAU

Robert Silbernagel

THE
History
PRESS

Published by The History Press
Charleston, SC
www.historypress.com

Front cover, top, left to right: Cowboy Joe Harris in Grand Junction. Date unknown. *Museums of Western Colorado;* a mail truck crossing deep wash in eastern Utah, circa 1916. *Museum of Moab*; Uintah Railway train crew with a locomotive in Atchee, Colorado, circa 1915. *Museums of Western Colorado.*
Front cover, bottom: Carnegie horses encounter an automobile near Jensen, Utah, circa 1915. *National Park Service, Dinosaur National Monument.*
Back cover: John Wesley Powell's boat in Marble Canyon on the Colorado River, 1872. *National Park Service, Grand Canyon National Park, The Powell Expedition Photo Gallery, Image No. 17249.*

First published 2018

Manufactured in the United States

ISBN 9781467138109

Library of Congress Control Number: 2017963921

Notice: The information in this book is true and complete to the best of our knowledge. It is offered without guarantee on the part of the author or The History Press. The author and The History Press disclaim all liability in connection with the use of this book.

This book is dedicated to all those who are fascinated by the Colorado Plateau and the stories of those who came before us.

CONTENTS

CONTENTS

FOREWORD

Robert Silbernagel, known to his friends as Bob, was a reporter for the *Daily Sentinel* in Grand Junction, Colorado, when I first met him in 1988. He covered the county beat at the time. The Museum of Western Colorado was on his radar, and I was the museum's executive director.

At the time, the museum's board of directors was negotiating with the City of Grand Junction and a private landowner for property on which to build a new museum complex. Meetings with the landowner were delicate, and it was critical that we maintain a level of secrecy. It was then Bob called and introduced himself to me as a reporter and stated that he was doing a story on the museum's planned move to the property in question (and here I thought it was secret). "No, absolutely not, you can't run with that now," I said. Well, that's not something you tell a reporter. Bob politely replied that the news was already "on the street." He wanted a quote from me, but more importantly, he said he wanted to get the story right.

The story ran, and the deal fell through, but not because of the story. This was my first recollection of working with Bob, and what I remember most about it was Bob saying, "I WANT TO GET IT RIGHT."

Since those days, Bob and I have become good friends, sharing stories and kicking around the Colorado Plateau, chasing down stories of early fur traders and hermits or remnants of wrecked locomotives. Stories about those historical items have appeared in his newspaper columns and in this book.

From his position as reporter for the *Sentinel*, Bob was later promoted to editorial page editor, a prestigious position he held for nineteen years. He became an important voice of western Colorado opinions and issues, while his passion for history continued to occupy much of his spare time.

As Bob was writing about the pressing issues affecting western Colorado, I was working with my museum staff in building a new museum on Main Street called Dinosaur Valley. Later, those efforts evolved into another museum in Fruita, Colorado, just west of Grand Junction. The Devil's Canyon Science and Learning Center focused on dinosaurs and fossils of western Colorado. Bob has continued to take great interest in regional history and the major fossil finds near Grand Junction, some of which had made headlines back east in the early twentieth century.

Occasionally, Bob's editorials would encourage and applaud the museum's efforts to reclaim its title as the "Dinosaur Capital of the West." After all, according to an early article in the *Boston Globe*, it was in Grand Junction where the "world's largest dinosaur was discovered."

While I was working at the Fruita dinosaur museum, I suggested that Bob write a book about the history of dinosaur discoveries of the area. Bob took that to heart and became relentless in pursuit of the history that put Grand Junction paleontology on the map. After many interviews and considerable research, Bob's first book, *Dinosaur Stalkers: Tracking Dinosaurs in Western Colorado and Eastern Utah*, was published in 1996 in collaboration with the Museum of Western Colorado, U.S. Bureau of Land Management and Dinamation International Society.

In 2011, the University of Utah Press published Bob's book *Troubled Trails: The Meeker Affair and the Expulsion of Utes from Colorado*, which was widely acclaimed. Bob's meticulous research revealed little-known facts about a tragic incident and recounted Ute versions of the affair. His research even took him by horseback along some of the oft-forgotten trails used by the Utes as they held captive three women and two children for twenty-three days.

Bob retired from the *Sentinel* in 2014 and finally had the time to pursue his passion, western history. The *Sentinel*'s publisher enthusiastically supported his desire to continue writing a history column for the paper. Bob's columns have taken readers throughout Colorado and eastern Utah on one adventure after another. He has spent countless hours in museums, libraries and archives in the West. Why? Because he "WANTED TO GET IT RIGHT."

Nostalgia for the past seems to bring us a measure of relief from a chaotic world. Bob's history columns have become increasingly popular in

the *Daily Sentinel*. With anticipation, we readers look forward to perusing his columns first before moving on to the news of the day. Many times, as I was preparing for a program or to lead a history tour, I have wished that I had saved his articles.

Now, we readers are truly fortunate to have a book based on many of Bob's columns in the *Sentinel*, columns that relate human efforts to live and travel on the Colorado Plateau. It is the kind of book you will be proud to have on your table or in your library. No doubt it will be dog-eared and well-used before long.

As you read with fascination the stories of the past in this book, you will appreciate even more that Bob "WANTED TO GET IT RIGHT."

MIKE PERRY
Retired Executive Director
Museums of Western Colorado
Fruita, Colorado

ACKNOWLEDGEMENTS

No author works alone, particularly when it comes to researching and writing about history. Many people contribute ideas, share books and articles and offer research assistance and encouragement. For the stories that appear in this book, several people and organizations deserve special recognition.

First, the chapters in this book are based on the history columns I write for the *Daily Sentinel* newspaper in Grand Junction, Colorado. The continuing support of Jay Seaton, publisher of the *Sentinel*, Mike Wiggins, the managing editor, and many others who help edit and publish my columns has been invaluable. So has the access to the *Sentinel's* archives.

Equally important has been the assistance of the Museums of Western Colorado in Grand Junction. Much of my research has been conducted in the museums' Lloyd Files Research Library, and many of the photos in this book are used courtesy of the museums. Often, information I used for a particular column or book chapter was dug out of the museums' archives by Erin Schmitz, the director of the research library; David Bailey, the museums' curator of history; or by great volunteers such as Marie Tipping. Their assistance is available to anyone interested in regional history, not just desperate writers. Peter Booth, the executive director of the Museums of Western Colorado, has unfailingly supported my efforts to write newspaper columns and this book.

Other institutions have also been important in my research.

ACKNOWLEDGEMENTS

Mesa County Libraries in Grand Junction has been a great source for historic periodicals from the region. And the staff have helped me track down needed books from other libraries.

The Museum of Moab in Moab, Utah, provided critical assistance in tracking down photos and archival information from that area.

The Museum of Northwestern Colorado in Craig, Colorado, provided important photos and information about Brown's Park and other areas in the northwestern part of Colorado.

Additional entities that offered assistance, photos or historical documents include:

- The U.S. Bureau of Land Management: Grand Junction Field Office and Uncompahgre Field Office
- The National Park Service: Dinosaur National Monument, Glen Canyon National Recreation Area and Grand Canyon National Park
- The Delta County, Colorado, Historical Society
- The Mesa County, Colorado, Historical Society
- The Palisade, Colorado, Historical Society
- The San Juan County, Utah, Historical Society
- The Old Spanish Trail Association
- The Interpretive Association of Western Colorado
- Dominquez Archaeological Research Group, Grand Junction, Colorado
- Centuries Research and Steven G. Baker, Montrose, Colorado
- Alpine Archaeological Consultants and Jon Horn, Montrose, Colorado

A number of individuals also deserve special mention.

Mike Perry, who wrote the foreword to this book, joined me on several research expeditions and has long encouraged my interest in history, as well as my efforts to get this book published.

Zebulon Miracle, with Gateway Canyons Resorts, also joined on a number of expeditions and provided invaluable assistance and advice when I hit a roadblock in research.

Various people with The History Press helped me keep focused and keep this project on track.

And, as always, my wife, Judy Silbernagel, joined me on expeditions and was my chief proofreader, critic and source of encouragement.

Finally, readers of my *Daily Sentinel* history columns have repeatedly told me how much they enjoyed the columns, have offered numerous suggestions for more stories and have suggested I publish a book based on my columns. Without their feedback and encouragement, there would be no columns or book. Thank you, to all readers.

INTRODUCTION

The Colorado River "is a veritable dragon, loud in its dangerous lair, defiant, fierce, opposing utility everywhere, refusing absolutely to be bridled by Commerce," Frederick S. Dellenbaugh wrote in 1902.

Dellenbaugh was a member of John Wesley Powell's second expedition down the Green and Colorado Rivers in 1871–72. And he was right. The Colorado and its tributaries were never harnessed for commercial transportation.

Even in the twenty-first century, although the rivers of the Colorado Plateau have been used for irrigation, hydroelectricity and recreation, they aren't used as aquatic highways.

Furthermore, these rivers have created a labyrinth of deep gorges interspersed with mesas and mountains that make even foot and horseback travel difficult. The rugged terrain is so carved and eroded that wheeled transportation—horse-drawn wagons and carts, followed by railroads and automobiles—didn't arrive on the Plateau until much later than in most of North America.

On the other hand, the Plateau's unique geology, its stunning rock formations and its multitude of scenic canyons make it home to nearly thirty national parks, monuments and recreation areas and other federally protected areas.

Although its exact boundaries are ambiguous, the Colorado Plateau encompasses approximately 130,000 square miles—roughly the size of Pennsylvania, Ohio and Kentucky combined. It covers large portions of

four states: Colorado, Utah, New Mexico and Arizona. It is mainly high-desert country, with some interspersed mountain ranges and forests. This book mainly focuses on the northern half of the Colorado Plateau, but some of the events described in it also involved the southern part, including the Grand Canyon.

The Plateau is drained primarily by the Colorado River and tributaries. The Colorado River headwaters are in the Rocky Mountains of Colorado, and the river flows 1,450 miles to the Gulf of California. It drains a region of 246,000 square miles, aided by tributaries such as the Green, Gunnison and San Juan Rivers, which have cut deep chasms across the landscape. A host of smaller streams like the Dolores, Duchesne, Dirty Devil, Price, Yampa and White Rivers have carved out their own canyons, thus significantly increasing travel impediments.

Despite these obstacles, however, humans here seem to have a passion for frequent journeys—or at least a casual disregard for the inconvenience and hazards they may encounter. The chapters in this book highlight that spirit.

During my thirty-eight years as a journalist working in this region, and as a recreational explorer of the Colorado Plateau and an ardent reader of its history, I've come to understand that extensive travel and a restless nature have long been characteristics of its people. When I began writing history columns for the *Daily Sentinel* newspaper in Grand Junction, Colorado, I tried to present interesting stories about the people and the problems they encountered in western Colorado and eastern Utah, the northern half of the Colorado Plateau.

The book is divided into eight sections.

Section I looks at some of the earliest inhabitants of the Plateau, offering glimpses of how they lived and traveled.

Section II examines stories of the early European explorers, from those seeking new territories and religious converts to merchants finding new locations and trails to conduct business.

In Section III, readers will learn of efforts to explore the Colorado River and its tributaries, as well as some of the attempts to harness the rivers for commercial activities.

Ranchers, farmers and homesteaders arrived on the Colorado Plateau in the second half of the nineteenth century. Some of their stories, the hardships they endured and the conflicts that occurred are told in Section IV.

Miners began arriving on the Plateau about the same time as the ranchers and homesteaders. Section V looks at some of their stories, from mineral wealth lost to booms that never materialized to long-term development.

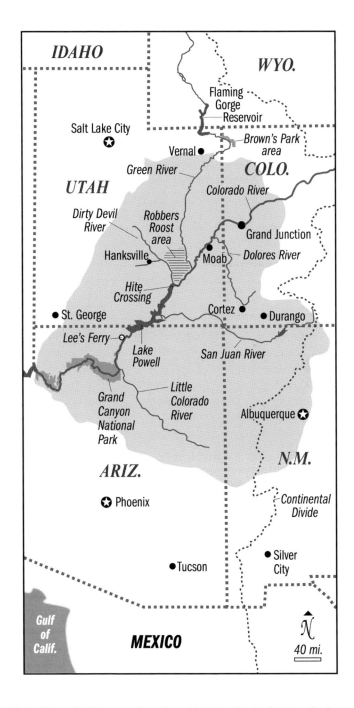

Map of the Colorado Plateau region. *Created by Robert Garcia. Author's collection.*

I can't discuss historic travel on the Colorado Plateau without mentioning outlaws. Several of the most notorious outlaws and some of their most famous crimes occurred here. Furthermore, Robbers Roost provided a hideaway in the heart of the Plateau for many different outlaw gangs. Section VI provides glimpses of outlaw life.

Mechanized transportation arrived on the Plateau eventually, first with railroads, then automobiles and finally airplanes. Section VII focuses on a few unique examples of those developments.

Section VIII examines some forms of recreation that developed on the Plateau, including rural dances, adventure river rafting and visiting backcountry sites that show evidence of past cultures.

The bibliography explains what I relied on for my research and provides readers with a means to dig into these stories in greater detail.

This book contains thirty-one chapters based on columns I wrote for the *Sentinel*. Each narrative is part of the broader story of humans constantly on the move in one of the most inhospitable places on earth to travel.

ROBERT SILBERNAGEL
Palisade, Colorado
July 2017

I

THE EARLIEST TRAVELERS

1

EARLY HUMANS FOUND SHELTER ALONG GUNNISON RIVER

(11,000 BC—AD 1800)

Thirteen thousand years ago, when the earliest inhabitants of Eagle Rock Shelter crouched around a hearth under a rock overhang along the Gunnison River in Western Colorado, the climate was far different from today.

Spruce-fir forests probably covered much of the plateaus above the river, where rabbit bush and sagebrush now are dominant. Annual rainfall was likely double what it is now—around twenty to twenty-five inches a year.

That's because thirteen thousand years ago, huge ice sheets still covered much of the Northern Hemisphere. Farther south, in what's now western Colorado, the climate was more moderate but still much different from the arid high desert of today.

Eagle Rock Shelter is the name given by archaeologists to a small but ancient site on federal Bureau of Land Management (BLM) property a few miles east of the town of Delta, Colorado. It is located on the edge of low, shale cliffs within the BLM's Gunnison Gorge National Conservation Area.

Carbon dating shows that people lived there at least 12,800 years ago. But there is evidence of people also living there 8,000 years ago, 5,000 years ago, 2,600 years ago and, much more recently, during the time of the Ute Indians, when Europeans and Americans began to move into the Southwest.

When people first made Eagle Rock Shelter their home, agriculture had yet to be invented. Humans picked wild grains, but they didn't plant and cultivate grains or other crops.

The Great Pyramids of Egypt had not been built. That wouldn't occur for another 8,400 years. Fledgling civilizations in the Tigris, Euphrates and Nile River Valleys were still more than 7,000 years in the future.

The climate has warmed, and the Gunnison River has changed its channel many times during the thousands of years since the earliest habitation, according to Glade Hadden, retired archaeologist with the BLM in Montrose, Colorado. Hadden oversaw work on Eagle Rock Shelter for more than a decade.

But even today, he said, it's not hard to understand why people chose the site. It's near the only place for many miles where big game animals cross the river. There is easy access to year-round water, and the shelter has direct southern exposure and great views—whether for aesthetics or to see enemies approaching—up and down the river.

It probably wasn't a year-round home but a seasonal one, used mostly in the winter when weather in the higher mountains was less bearable.

Eagle Rock Shelter isn't alone. Across North America, there is limited evidence of human occupation as early as 15,500 years ago. A few discoveries suggest possible human activity on this continent as early as 22,000 years ago.

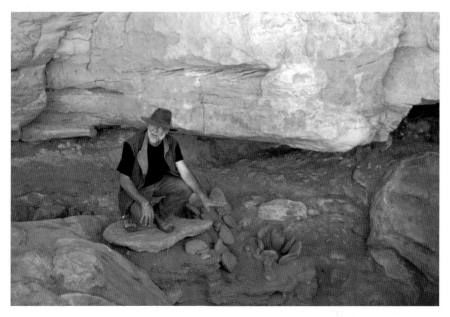

Bureau of Land Management archaeologist Glade Hadden, now retired, explaining work at Eagle Rock Shelter. *Photo by the author.*

Eagle Rock Shelter is one of two sites showing the earliest evidence of human occupation in Colorado. The other is in Douglas County, near Denver. The earliest human habitation on the Colorado Plateau is found at Eagle Rock.

At Eagle Rock and a handful of other sites across the country, archaeologists have found stone points that predate the Clovis style of points, which were once considered the oldest in North America. The type of points found at Eagle Rock Shelter are known as Great Basin Stemmed Points and are a subset of artifacts called Western Stemmed Points.

They raise questions about where these early inhabitants of Colorado came from and how they got here. The long-held archaeological theory is that the first inhabitants of North America crossed from Asia to North America on a land bridge during the last ice age, then spread out across the continent.

But an alternative theory, now gaining traction and linked to Western Stemmed Points, suggests that people from Japan and nearby parts of Asia may have used boats to cross the ocean south of the Bering Strait, then traveled down the Pacific coast, moving inland at encouraging locations.

If that's the case, the ancestors of the people who first lived at Eagle Rock Shelter may have come ashore in California or Oregon and would have had a much shorter trek to reach western Colorado than those who hiked south from the ice bridge.

The earliest Eagle Rock Shelter residents were also different from early residents in other parts of the continent because they didn't hunt giant mammals such as mammoths and ancient bison.

"We mostly find rabbit bones and sage grouse" in the ancient fire pits at the shelter, Hadden said. "We don't find big-game bones."

However, archaeologists did find the second-oldest basket in North America at Eagle Rock. It is made of yucca fibers and is approximately seven thousand years old.

Additionally, there was corn from roughly 600 BC, the time of the people we now call the Fremont culture. It is some of the earliest corn found in this region.

Interestingly, Hadden noted that although farming helped the Fremont people live a more settled life, it didn't make them live longer. In fact, it shortened their life spans.

"Studies show hunter-gatherers worked fifteen to twenty hours a week and most lived sixty to seventy years" if they survived infancy and weren't killed in battle or an accident. In contrast, the Fremont farmers lived an average

of only forty-five years, Hadden said, in large part because their teeth wore down earlier due to the fact they ground their corn on rock metatés.

Eagle Rock Shelter has been recognized for decades, but it hadn't been carefully examined until Hadden began exploring it in 2006. He and the BLM eventually joined forces with a team of archaeologists from Western Wyoming Community College to carefully excavate and record items found in the shelter. They did so with the cooperation of the Ute Indians whose ancestors once lived in the area.

All the artifacts have now been removed from the site by archaeologists and archived, with permission from the Utes.

2

NATIVES HAD THEIR OWN HIGHWAY NETWORKS

(Unknown—AD 1850)

A t the big bend of the Dolores River in southwestern Colorado, several ancient trails dispersed. To the west was a well-known path to the Colorado River at today's Moab, Utah. That route is now known as the Main Branch of the Old Spanish Trail, and it became an important trade route in the early nineteenth century.

To the east was a pathway that led to the top of the Uncompahgre Plateau and eventually the Gunnison River near today's Delta, Colorado. Parts of it were called the Navajo Trail–Uncompahgre Trail, but its importance as an ancient trail was largely forgotten until Montrose anthropologist and archaeologist Steven G. Baker rediscovered old documents that demonstrated its ancient usage.

These trails and many more were used by a variety of native people over the ages, according to Carl Conner, owner of Grand River Institute, an archaeological consulting firm in Grand Junction. He is also founder of the Dominquez Archaeological Research Group, or DARG, a nonprofit organization.

In the Piceance Basin of western Colorado, there is plenty of proof of the Utes who frequented the area in the nineteenth century. But Conner and his team have also found evidence of the Fremont culture, as well as Shoshones, Navajos and early ancestors of the Navajos. And there are traces of Dismal River culture, believed to be ancestors of the Apaches.

Archaeologists have found shell beads, which originated on the Pacific coast, in western Colorado and obsidian from Wyoming, New Mexico and

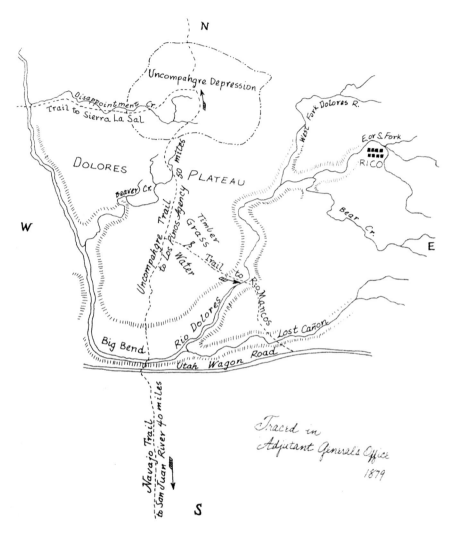

Tracing of an original tracing of the 1879 map, prepared by Captain Edward Hatch of the Ninth U.S. Cavalry Regiment, showing portions of the Navajo and Uncompahgre Trail. *Steven G. Baker, Centuries Research.*

Colorado. Navajo rock art has been found atop the Uncompahgre Plateau, Conner said, an area long believed to primarily be the domain of the Utes in recent centuries.

And in an isolated canyon just north of Interstate 70 near the Colorado-Utah border, there are rock art panels that show evidence of thousands of years of native visitation, from Barrier Canyon style that is believed to be more than two thousand years old to Fremont art that was created from one

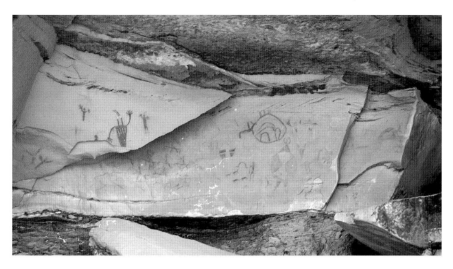

Rock art panel along ancient trail near Colorado-Utah border with evidence of thousands of years of native visitation. *Photo by author.*

thousand to five hundred years ago to Ute drawings showing human figures on horseback, which were made after the Utes had contact with Europeans.

Because we know traders, trappers and others traveled through this canyon in the nineteenth century to go from western Colorado to northeastern Utah, and because there are so many different styles of drawings over time, it is likely the trail through this canyon was an ancient north–south route.

Clearly, many people moved across the Colorado Plateau, whether trading, traveling, visiting or relocating. And they almost certainly had a number of long-established routes for doing so.

Through DARG, Conner and project coordinator Richard Ott have undertaken the Ute Trails Project, attempting to trace major trails or routes in western Colorado. The project grew out of DARG's Wickiup Project, which has recorded and examined old Ute habitation sites in Colorado. The work is performed in cooperation with Ute Indian tribes and federal land management agencies. It is expanding into several related projects.

"We wanted to take more of a landscape approach rather than just a site-by-site look," Conner explained. "We wanted to try to discern how these sites relate to each other, with trails."

One such trail is the path taken by two Spanish friars, Fray Francisco Atanasio Domínguez and Fray Silvestre Vélez de Escalante, in 1776, when they were led by Ute guides along native pathways. Several times in his

journal of the expedition, Escalante remarked about traveling "a very wide and well-beaten trail."

Conner and Ott have also examined a route from south-central Wyoming that runs south past Browns Park in Colorado and on toward the Piceance Basin. The researchers found water holes roughly every twenty-five miles, Ott said, which makes sense for people traveling on horseback. The route may have been used by Utes who traveled north to raid for horses and returned to their own territory with the stolen animals.

Access to water was key to another route they investigated, on the advice of modern Ute leaders, from the Dolores River south of Gateway, Colorado, over the Uncompahgre Plateau to the Gunnison River near Big Dominguez Canyon. The route is more than thirty-five miles in a straight line, but water was available at both ends.

It's not just rivers. Mountain passes, many of which today accommodate modern highways, were also used long ago by Utes and others.

On some passes, artifacts dating back thousands of years have been discovered. Others show only more recent inhabitation or visitation. Evidence of early travel and visitation has been found on Vail Pass, Cerro Summit, Cottonwood Pass near Glenwood Springs, Cochetopa Pass near the San Luis Valley and Ute Pass, which connected Colorado Springs and South Park.

Perhaps no prehistoric trail in the Southwest is as famous the Chaco Meridian, which runs almost arrow-straight from Aztec, New Mexico, through the Chaco Canyon complex in northern New Mexico and south to a prehistoric site in Sonora, Mexico. University of Colorado archaeologist and author Stephen H. Lekson has detailed how the Ancestral Puebloan people of the Chacoan culture could have surveyed the straight roads a thousand years ago with only a few degrees of error.

Archaeologists have long known there was trade between southern parts of Mexico and places like Chaco. Macaw and parrot feathers, copper and beads from far to the south have been found at Chaco and related sites.

Although many ancient routes became horse trails, wagon roads and eventually highways, many more did not. People on foot could go up and over obstacles far more easily than those pulling wagons or even riding horseback. As Lekson put it, "Pueblo trails and Chacoan roads, whether symbolic or functional, were not bridle paths....Wagon roads, developed for new transportation technologies, may not represent the most important ancient routes."

For instance, there were well-documented old trails, such as the route across the Flat Tops in northwestern Colorado from the Colorado River east of Glenwood Springs, Colorado, to the White River near Meeker, Colorado. The trail was frequented by Utes and other native peoples, but it never developed into a route for wagons, railroads or autos.

The Ute Trail Project undertaken by Conner, Ott and DARG can't identify and map all of the numerous trails used by Ute Indians in this region. But their work will give people a better understanding of some of the major pathways used by the Utes and other native people.

3

UTES BECAME SKILLED EQUESTRIANS OF THE MOUNTAINS

(1640–Present)

The Comanche and Cheyenne, the Sioux, Arapaho, Crow and Blackfoot all became noted for their exploits on horseback. But the Utes of western Colorado and eastern Utah, one of the first tribes north of New Mexico to acquire horses, also developed a well-earned reputation for superior equestrian skills, especially in their rugged homeland on the Colorado Plateau.

Edward F. Beale, an experienced horseman and mid-nineteenth century explorer who traversed the continent a half-dozen times on horseback, was astonished by what he experienced in 1853, when he visited Utes in the Uncompahgre Valley of western Colorado:

> Went out this morning with the Indians to hunt. They lent me a fine horse; but God forbid that I should ever hunt with such Indians again! I thought I had seen something of rough riding before; but all my experience faded before that of the feats of today. Some places which we ascended and descended it seemed to me that even a wild-cat could hardly have passed over; and yet their active and thoroughly well-trained horses took them as part of the sport, and never made a misstep or blunder during the entire day.

Like other natives of North America, the Utes had spent centuries hiking over mountains and deserts with nothing more than large dogs to assist them as pack animals. When Spanish colonists in New Mexico introduced them to horses, the Utes' way of life changed tremendously. They could travel more

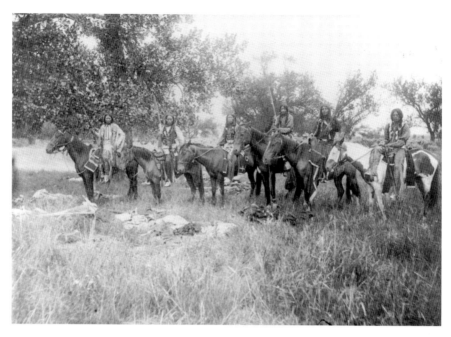

Ute men on horses in Colorado or Utah, circa 1905. *Library of Congress.*

widely within their intermountain territory, and some Utes began to make seasonal trips to Texas and the Oklahoma Panhandle, to Colorado's Eastern Plains and to western Kansas, risking encounters with enemy tribes because they had a speedy means of escape.

Horses also made it possible for Utes to adopt the Plains Indian teepee, made of buffalo hides and long lodge poles, which could be transported by horses when they moved camps, but they didn't abandon their traditional stick-and-brush wickiups for shelter and storage. It wasn't long before an individual Ute's wealth was measured by the number of his ponies.

Utes living closest to Santa Fe—in southwestern Colorado and northern New Mexico—no doubt acquired horses first. It is believed that Utes from that region who were captured in 1637 by the Spanish escaped in 1640 and took a number of Spanish horses with them. More horses were likely acquired during the Pueblo Revolt of 1680 and through trading and raiding in subsequent decades.

One twentieth-century author, Frank Gilbert Roe, argued the Utes spread horses and equestrian culture north through their mountain homeland, then west to the Shoshones and Nez Pearce and east to the Comanche, Cheyenne and Arapaho.

Others have disputed Roe's arguments. Many archaeologists and historians believe that horse ownership primarily spread up the east side of the Rocky Mountains, across the Great Plains and eventually to tribes in the Northwest, rather than through the Utes' mountainous homeland. Moreover, they argue that there is little evidence of the great Ute horse culture in most of Ute territory until the end of the eighteenth century or beginning of the nineteenth century.

The first European visitors to Ute territory left a sketchy view of Ute horse culture. In 1765, when Juan Rivera traveled from New Mexico to what's now western Colorado and met with several different groups of Utes and Paiutes, he said little about their horses. He did mention several times providing mounts for Ute leaders or guides who were to accompany his men on part of their journey.

Eleven years later, when the Franciscan fathers Fray Francisco Atanasio Domínguez and Fray Silvestre Vélez de Escalante arrived in the region, they were impressed with the horses of the Sabuagana Utes they met on Grand Mesa, east of today's Grand Junction, Colorado. On September 1, 1776, Escalante wrote that the expedition had met "about eighty Yutas *all* on good horses" (emphasis added). Furthermore, those Utes had enough good horses that they were willing to trade the Spaniards for some of the expedition's footsore mounts.

By the early nineteenth century, horses and horse culture dominated Ute life in western Colorado and much of Utah. Consequently, observations like those of Edward Beale were not unusual for early Americans who encountered mounted Ute Indians.

Famed fur trader William Ashley said in the 1820s that the Utes generally had better mounts than the Plains Indians to the east, and they had more horses per person than most other tribes. Later in the century, two Denver journalists wrote that Ute ponies could carry a rider one hundred miles in a day, climb steep mountains, swim river torrents and subsist on mountain grass in summer and winter.

Horses were important enough to the Utes that one early agreement between the U.S. government and the Uncompahgre Utes of central-western Colorado said the government would provide five well-bred American stallions to the Utes to help replenish and improve their herds. Unfortunately, as with so many other agreements between the United States and Indian tribes, the provision was never fulfilled.

The Utes valued their horses so much that one American visitor to Hot Sulfur Springs in northwestern Colorado in 1868 found that Utes who came

to soak in the healing waters of the hot springs took their ailing horses into the hot pools as well.

Disputes over horses and a racetrack were among the many problems that, in 1879, led to animosity between the White River Utes and their Indian agent, Nathan Meeker. That animosity culminated in late September with a battle between Utes and the U.S. Army at Milk Creek, north of the White River, and the killing of Meeker and his male employees at the White River Indian Agency.

As a result of those incidents, most of the Utes in Colorado were forcibly removed to reservations in northeastern Utah. When they left, thousands of horses that had once belonged to them disappeared. Some may have been killed by U.S. Army troops. Many more were believed to have been captured by white settlers. A few ran free and formed the foundation for herds of wild horses that still exist in Colorado.

HIDDEN FROM HISTORY, UTE WICKIUPS ALTER THE NARRATIVE

(1795–1916)

Wickiups offer a glimpse into the past—into the way Ute Indians lived in the rugged terrain of the Colorado Plateau. And they have forced archaeologists to reexamine a long-held narrative about the Utes.

Wickiups were small wooden shelters constructed by standing tree limbs together in a conical pattern and covering them with brush. Some were freestanding, and some were built leaning against an existing tree or rock formation. Most were much smaller than the hide-covered tepees that were adopted from Plains Indians.

"Think of them as a bedroom, with just enough room for a man and his wife and their dog," said Curtis Martin, an archaeologist who has studied wickiups in Colorado for fifteen years.

Other structures made of similar materials were used to store goods or corral livestock.

The long-held and mostly correct narrative is that Uncompahgre and White River bands of Utes left Colorado in 1881, when they were pushed out of their homeland by the U.S. government and forced onto the Uintah-Ouray reservation in northeastern Utah. Many later briefly returned to Colorado to hunt or visit.

However, there is now evidence that not all the Utes from those two bands left the state in 1881. Some may have lived as inconspicuously as possible in their beloved homeland long after the forced removal.

"Over half the sites we've firmly dated [using tree-ring data and carbon dating] are post-1881," said Martin, who is the principal investigator for the

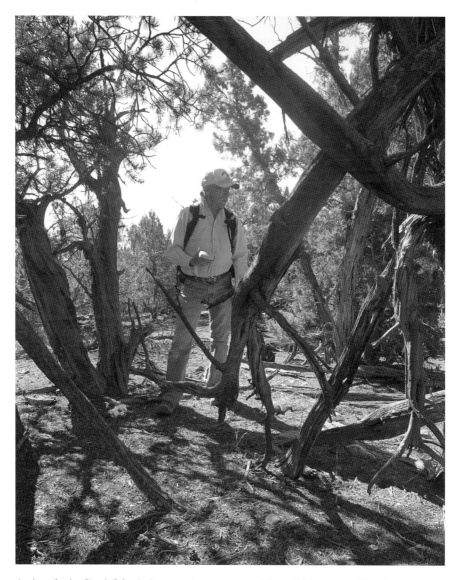

Archaeologist Curtis Martin inspects the remnants of Ute wickiup, 2013. *Photo by the author.*

Colorado Wickiup Project and author of a book on the project's findings. A few sites are as recent as 1914 and 1916, decades after the Utes were supposedly expelled from most of Colorado.

Martin and his team began in 2003, examining the remnants of Ute wickiups and other wooden structures from the Uncompahgre Plateau in

west-central Colorado to Rocky Mountain National Park, which lies atop the Continental Divide in northern Colorado. The team also examined many structures in the Colorado River and Piceance Basins. As of 2016, they had documented more than four hundred structures at eighty-six sites.

Not all the examined sites were of recent vintage. One dated from 1795, and it showed evidence of Ute horse culture. Another, which I visited with Martin in 2013, was occupied between 1800 and 1860. There is no tree-ring data for this site, but metal arrowheads and a metal awl found by researchers give archaeologists a reasonable time frame for when it was used.

When Martin visits the remnants of an old campsite—say one that is 120 to 150 years old—he can often determine by the trash residue if it was occupied by white people or Ute Indians.

"The white men just threw away their tin cans," Martin explained. "The Indians were more resourceful. They recycled the cans, making arrow points" and other useful items from the metal they had acquired from whites.

"One of the most interesting things we discovered was how rapidly horses and trade goods were adopted into the Ute lifestyle," Martin said. "In one generation they went from stone tools to metal arrow points to guns."

The rapid nature of that change, along with the presence of so many different types of trade goods, indicates how widely the Utes traveled within and beyond the rough terrain of their homeland.

Trade goods found on sites, such as various styles of metal tools, bullets and rifle cartridges, horse tack and even glass beads, can provide clues to the dates of an encampment. Glass beads, which Indians used for decorations, were traded by Europeans to Indians throughout North America.

Many of the beads were manufactured in Venice, Italy. As bead-making technology improved over many years, the beads became smaller and the methods of producing them changed. As a result, Martin and his crew can now estimate within a few decades when a site was occupied just by examining the size and style of glass beads found.

Earlier sites, which have no evidence of trade goods, are more difficult to date.

Until the Utes had metal axes, they simply collected dead wood to construct their wickiups, Martin said. So, while it's possible to use tree-rings or carbon dating to determine when branches used in such a structure were alive and how old the tree was, there is no way of knowing how long they may have been dead before they were collected by Indians.

Modern Utes have told Martin and his team that Ute settlement patterns changed after 1881. They moved away from rivers and trails. It's no surprise,

then, that the most recent wickiup sites were well away from major roads or trails used by white settlers.

The Colorado Wickiup Project has been an effort of the Dominquez Archaeological Research Group, which is a nonprofit organization associated with the Grand River Institute, a private archaeological business in Grand Junction. The project has received funding primarily from the Colorado Historical Society State Historical Fund and federal agencies such as the Bureau of Land Management, the U.S. Forest Service and the National Park Service. It also works closely with representatives of Ute Indian tribes in Colorado and Utah. The Wickiup Project is continuing under the auspices of Colorado Mesa University in Grand Junction.

II

EXPLORERS
AND TRADERS

5

JUAN RIVERA COMES CALLING

(1765)

In 1765, a small group of explorers, traders and Indians, led by Juan Maria Antonio de Rivera, left the outpost community of Abiquiu, New Mexico, and headed northwest. They were looking for silver. They were searching for the Rio Tizon and the heavily bearded men who looked like Europeans that were said to live near the river. And they hoped to find the great community that some believed was home to multiple Indian tribes.

They first traveled into the Tierra de Guerra—the Land of War—a high-desert no-man's land north and west of Abiquiu. The disputed territory had few permanent inhabitants, but it was the site of frequent conflict among several Indian tribes and a staging ground for Indian raids on Spanish settlements.

Their trip across the Tierra de Guerra was largely uneventful. But the journey became more difficult as they entered what's now western Colorado and portions of the Colorado Plateau that were largely unknown to Europeans. In July, Rivera and his men crossed the swollen Animas River near today's town of Durango, Colorado.

"The water came up on the horses above the hind bow of the saddle," Rivera wrote in his journal for July 5, 1765. It took a full day to get fifteen men, scores of horses and mules and their supplies successfully across the roiling river.

Rivera was headed toward the Rio Tizon, today known as the Colorado River. He hoped to go beyond that to Teguayo, a land reported

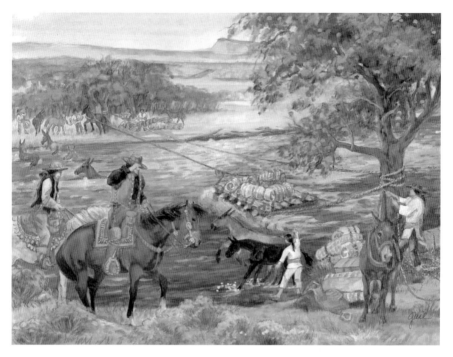

The Rivera company crossing the swollen Animas River on July 5, 1765. *Steven G. Baker, Centuries Research.*

to be heavily populated by a variety of Indians. The exact boundaries of Teguayo were unclear, but based on Spanish estimates of distance and descriptions of the land, it was near Utah Lake and the Great Salt Lake in north-central Utah.

Teguayo was also where heavily bearded men who might be Europeans were said to reside. Determining the truth of this persistent rumor was important because the people could be Spaniards stranded after sea voyages or descendants of early conquistadors. If so, they likely had critical information about the region. More worrisome was the possibility they were French or Russian intruders on lands the Spanish considered their own.

Rivera and his party also hoped to find silver deposits in the unexplored mountains north of New Mexico.

Rivera led two expeditions during the summer and autumn of 1765, traveling a total of 1,300 miles. Although he did find some silver, the expeditions failed to reach Teguayo or even the main stem of the Rio Tizon. But in the autumn of 1765, Rivera and his party arrived at the great ford of the Gunnison River, just west of present-day Delta, Colorado.

Even if Rivera didn't meet all of his objectives, there still were notable accomplishments.

For one thing, his journals provided "the first meaningful descriptions of Colorado," said author and anthropologist/archaeologist Steven Baker of Montrose, Colorado, author of *Juan Rivera's Colorado, 1765*. Other Europeans had visited Colorado's Eastern Plains and corners of western Colorado, but they left little record of what they encountered.

Additionally, Rivera provided the first significant description of Utes and Paiutes in their home territories. For more than a century before Rivera's expedition, the Spanish knew of the Utes, whom they called "Yutas," and who variously raided or traded with settlers in New Mexico. Prior to Rivera, however, there is no documented evidence of Europeans having traveled to the Indians' lands with instructions to peaceably interact and learn more about them.

Also, Rivera's trips laid the foundation for the expedition of Fray Francisco Atanasio Domínguez and Fray Silvestre Vélez de Escalante in 1776, when the Franciscan friars sought, in part, to complete Rivera's unfinished mission. The fathers traveled much farther than Rivera, to the Utah Lake region—the supposed Tequayo. There and along the Sevier River, they met bearded Ute Indians and put to rest the rumor of Europeans living there. They also dispelled the notion that there was a huge, multi-tribal community in the region.

On both of his 1765 trips, Rivera was accompanied by Joaquinillo Trujillo, a Kiowa *genizaro*. Genizaros were Indians who had been captured by the Spanish or purchased as slaves but had won their freedom over time and were therefore considered citizens of the Spanish colony. Trujillo spoke Ute and served as Rivera's interpreter.

In addition to about fifteen men, Rivera's expeditions included sixty or more horses and mules.

Rivera's accomplishments are the more remarkable because he was not a member of the Spanish aristocracy, nor was he a military or religious leader. Born in Chihuahua, Mexico, his major qualification for the assignment apparently was some limited mining experience.

He was chosen by Don Tomàs Vélez Cachupin, the Spanish governor of New Mexico, to head the expeditions to the Ute lands. Rivera's expeditions had Cachupin's blessing and possibly his personal financial support, but they were not sanctioned by and did not receive funding from the government of New Spain, which included all Spanish-claimed territories north of the Isthmus of Panama.

Isolated from wealthier communities such as Mexico City, and with a limited agrarian-based economy, the Spanish colony of New Mexico was desperate for ways to improve its finances. Discovering sources of mineral wealth would be a major accomplishment in that regard. Aware that a Ute man had brought a silver nugget from the northern mountains to Abiquiu several years earlier, Governor Cachupin instructed Rivera to find the silver ore.

That was accomplished in July 1765, when Rivera and his men connected with a Ute named Cuero de Lobo. Guided by him, Rivera and several members of his expedition journeyed to the La Plata Mountains northwest of present-day Durango, where Rivera proclaimed, "The whole sierra is pure ore." However, lacking suitable prospecting tools, the men were only able to use their knives to cut out a few small silver ore samples, which they carried back to Santa Fe.

More than a century later, prospectors and miners from the United States would confirm that there were, indeed, silver and veins of gold in Colorado's La Plata Mountains, although not to the extent Rivera claimed. The really valuable deposits were found to the north and east of where Rivera traveled, in the San Juan Mountains around the modern communities of Silverton, Ouray and Telluride, Colorado.

The governor also directed Rivera to search for a route to Teguayo and charged him with finding out as much as he could about the native people who resided on both sides of Rio Tizon. He hoped to accomplish this on his second expedition. But it was no easy jaunt.

First, their young Tabeguache Ute guides took them far off course. They had gone northwest as far as the Paradox Valley on the Dolores River in Colorado, where they endured one of the most difficult trail descents of the entire trip, endangering men, horses and mules. Packsaddles slid off mules as they picked their way down a steep and rocky Indian footpath in the face of a fierce north wind. When they reached the bottom, they found no place to camp, so they were forced to plod up an equally difficult trail on the opposite side of the Dolores River. But nearby, they found a good camp spot with water and pasture for their livestock.

A few days later, Rivera and his men spent a cold, miserable evening on top of the Uncompahgre Plateau, west of present-day Montrose, Colorado. "That night we had a furious storm of wind and rain," and they were unable to protect themselves from the harsh weather, Rivera wrote on October 14.

The next day was better, however, and after a march along the top of the Uncompahgre Plateau, then a difficult descent to the valley below, the

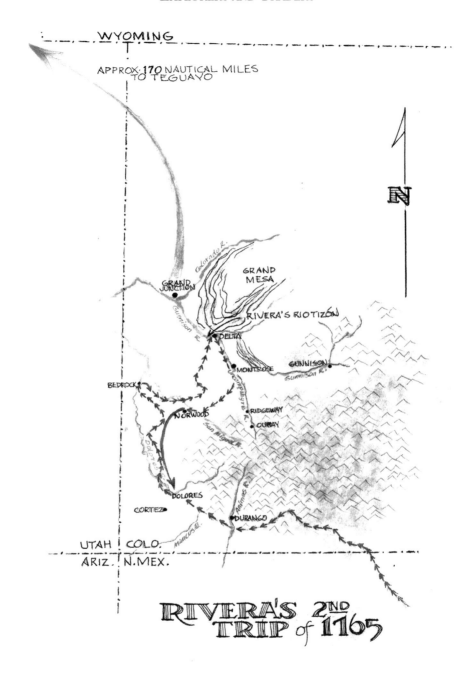

WYOMING

APPROX. 170 NAUTICAL MILES
TO TEGUAYO

N

Colorado R.

GRAND
JUNCTION

GRAND
MESA

Gunnison R.

RIVERA'S RIOTIZÓN

DELTA

MONTROSE

GUNNISON

Gunnison

BEDROCK

San Miguel R.

Uncompahgre R.

NORWOOD

RIDGEWAY

OURAY

Dolores R.

DOLORES

CORTEZ

Animas R.

DURANGO

Mancos R.

UTAH | COLO.
ARIZ. | N.MEX.

RIVERA'S 2ND
TRIP of 1765

Map of the second Juan Rivera expedition of 1765. *Steven G. Baker, Centuries Research.*

party finally reached the Gunnison River, which Rivera believed was the Rio Tizon. It was a welcome destination after weeks of difficult travel.

"We slept on its banks in a beautiful meadow," said Rivera's journal entry for October 15.

By heading so far north and west before cutting east across the Uncompahgre Plateau, the Tabeguache Ute guide apparently hoped to keep Rivera from connecting with Sabuagana Utes to the east. The Tabeguaches likely wanted to be the primary trading partners with the Spaniards, swapping buckskin and wild game for Spanish horses and other goods. But they weren't successful in keeping the trade to themselves.

At the Gunnison River, Rivera and his men met a party of Sabuaganas who talked and traded with them until October 20. The Sabuaganas then accompanied Rivera and his men south through the Uncompahgre Valley to their main village near present-day Montrose.

Both the Tabeguache and Sabuagana Utes warned Rivera of the dangers of traveling much farther north, telling him he and his men were likely to encounter hostile Comanches.

But it was more the lateness of the season and the weariness of his men and animals than fear of Comanches that led Rivera to turn homeward. He and his intrepid explorers left the Uncompahgre Valley on October 22 and returned to Abiquiu. They were in Santa Fe by November 20, when Rivera presented a report of his journeys to Cachupin.

Within a year or so, Rivera disappeared from the historical record.

The journals he wrote of his trips also vanished—for two hundred years. They were rediscovered in 1969 in military archives in Madrid, Spain.

6

DOMÍNGUEZ AND ESCALANTE ACHIEVED SUCCESS WITHOUT REACHING CALIFORNIA

(1776)

When Fray Silvestre Vélez de Escalante left Santa Fe, New Mexico, on July 29, 1776, with Fray Francisco Atanasio Domínguez and eight other companions, he knew the expedition's official mission was to find a suitable land route to California. But Escalante didn't expect to complete that assignment.

On the very day the mission embarked, Escalante wrote to his Franciscan superior in Santa Fe. He said that even with twice as many men, he didn't believe it was possible to reach Monterey, California.

Instead, Escalante proposed that the 1776 mission would "find out whether the Spaniards whom the Yutas [Utes] and others say are on the other side of the Rio Tizon [Colorado River] are really there and who they are, but not to go as far as Monterey."

Escalante, Domínguez and their crew completed the now-famous journey on January 2, 1777, having traveled roughly 1,700 miles on horseback across the Colorado Plateau, primarily in today's Colorado and Utah, but also in Arizona and New Mexico. They did not reach California, and that must have disappointed Spanish colonial leaders.

Although there had been Spaniards in New Mexico since 1598, with a brief absence following the 1680 Pueblo Revolt, a permanent Spanish presence in California had only been established in 1769. Monterey was founded in 1770.

In 1774, the viceroy of New Spain asked Franciscans to assist the colonial government in researching an overland route from New Mexico to Monterey. Domínguez and Escalante were among those enlisted.

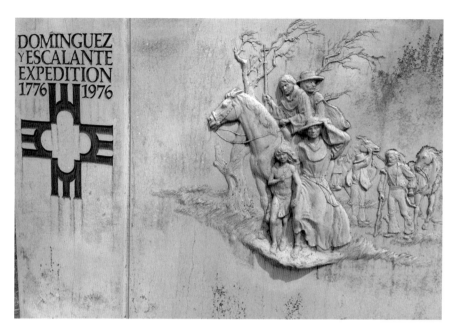

Relief depicting the Domínguez-Escalante Expedition of 1776. *History Colorado, Dominguez-Escalante Bicentennial Monument at the Ute Museum, Montrose, Colorado.*

Domínguez, the nominal leader of the 1776 expedition, was born about 1740 in Mexico. In 1775, he was sent to the New Mexico province to inspect the Franciscan missions there and to study possible overland routes to Monterey.

Escalante was ten years younger than Domínguez, but he seems to have directed much of the activity of the expedition. He was a native of Spain who had come to Mexico City in 1767 and was sent to New Mexico in 1774. He was assigned to the mission at the Zuni Pueblo west of Albuquerque.

In 1775, Escalante visited Hopi pueblos in today's north-central Arizona. There, he heard reports of the Grand Canyon and antagonistic tribes to the southwest. Consequently, Escalante told another Franciscan leader in August 1775 that an overland route to Monterey could not be due west, through Hopi country.

Escalante argued that it would be better for an expedition to head north and west through Ute country. In the process, they could investigate whether there were bearded men there who might be descended from members of Francisco Vázquez de Coronado's 1540 journey across the Southwest or from later Spanish expeditions.

Spanish authorities had long wondered whether the rumors of Spaniards living with the Indians were true, or if other Europeans lived north of the Rio Tizon.

Domínguez and Escalante put these concerns to rest in late September 1776 after reaching Utah Lake and then the Sevier River in southwestern Utah.

Escalante wrote that the Ute men in both areas wore beards, although those near the Sevier River had heavier beards. "In features they look more like Spaniards than like the other Indians hitherto known in America....It is they, perhaps, who gave rise to the reports of the Spaniards" living beyond the Rio Tizon.

Despite such success, the Domínguez-Escalante expedition faced its share of difficulty.

In early September, when they met with Sabuagana Utes on Grand Mesa, east of today's Grand Junction, Colorado, the Indians stridently warned Domínguez and Escalante not to continue northward because of the danger of encountering Comanche Indians. The priests, although

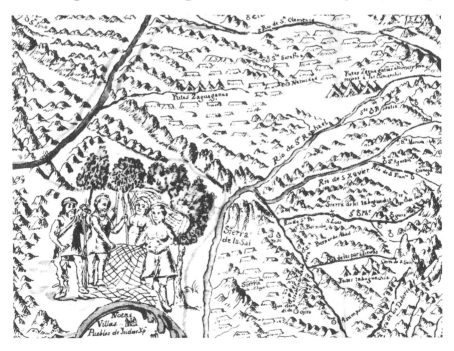

Bearded Ute Indians, as depicted on map by Bernardo de Miera y Pacheco, of the Dominguez-Escalante expedition. *History Colorado, Dominguez-Escalante Bicentennial Monument at the Ute Museum, Montrose, Colorado.*

unarmed, refused to change their plans, explaining that they trusted in God for their safe journey.

They also learned that several members of their own expedition were colluding with the Sabuaganas in trying to bring the expedition to a halt, and they determined that two expedition members, Andrés Muñiz and his brother Lucerio, had violated the terms they agreed to when they signed on with the expedition. They had secretly brought trade items with them and were covertly trading with the Utes, apparently trying to obtain arms from the Indians. The friars quickly ended these efforts to thwart their mission, although Escalante did not explain in his journal how that was accomplished.

Meanwhile, the Sabuaganas realized the friars were determined to continue northwest. So they agreed to trade fresh horses for some of the expedition's footsore and weary mounts. And they persuaded the expedition's Laguna Ute guide, who had joined the expedition when it reached the Gunnison River, to remain with the group. A second Laguna Ute also joined the group. The Laguna Utes lived near Utah Lake, so the guides were indispensable in leading them toward that region.

The expedition continued, and it did not encounter Comanches.

In a few days, the men had crossed the Roan Cliffs, north of the Colorado River, and were headed northwest when they reached a wide canyon with a well-traveled pathway. Halfway down the canyon, the group spotted ancient Indian rock art high on a cliff. "For this reason," Escalante wrote, "we called this valley Cañon Pintado," or Painted Canyon. The name is still used for the canyon just south of Rangely, Colorado.

By September 13, the group had arrived at the Green River near the present town of Jensen, Utah, and ten days later they arrived at Utah Lake. As they dropped into the valley where the lake is situated, Escalante reported, "all around us they were sending up smoke signals, one after another, thus spread the news of our coming."

They spent a few days there, successfully gathering Catholic converts among the Laguna Utes and receiving enthusiastic assurances from them that they would welcome Spanish settlers and a Catholic mission.

A few days after that success, however, while camped near the Beaver River in southwestern Utah, the priests faced a near mutiny over the critical issue of whether to continue on toward California.

The weather had turned bad, with snow falling for several days. Two scouts sent to search for a pass westward through the mountains failed to find one. The snow stopped and the weather warmed, but mud became a serious impediment. Their new Laguna guide ran off.

Even so, not all expedition members were eager to abandon the search for a route to California. Mapmaker Don Bernardo Miera y Pacheco, interpreter Andrés Muñiz and others were furious at the idea. Miera, for one, hoped to enhance his fortunes as an explorer, mapmaker and military leader by reaching Monterey.

On October 11, following an impassioned speech by Fray Domínguez about the dangers of continuing westward, they drew lots. The majority agreed to turn southeast and return to Santa Fe, and the others reluctantly accepted the decision.

Heading home, they struggled across rugged country on either side of what's now the Utah-Arizona border, running low on food. On October 23, they killed the first of several horses they would butcher to stay alive.

On October 26, they camped near what later became Lee's Ferry on the Colorado River, and they began an eleven-day search for a suitable place to cross the wide and swift-running water. Finally, on November 7, they descended a steep canyon trail and made it safely across the river about twenty miles upstream from Lee's Ferry. The Crossing of the Fathers, as it became known, is now covered by the water of Lake Powell.

On November 17, they reached the Hopi Pueblo Oraibe in north-central Arizona, which Escalante had visited in 1775. A week later, after a rapid and exhausting push eastward, they reached the Zuni Pueblo west of Albuquerque, where Escalante had previously served.

From there, it would have been a quick trip to Albuquerque and northeast to Santa Fe if they hadn't been stalled by a series of snowstorms. But they persevered and finally reached the New Mexico capital on January 2, 1777.

Despite the fact they didn't reach California, Domínguez and Escalante had put to rest the rumors of bearded Europeans living northwest of the Colorado River. They were also successful in gathering religious converts among the natives, and they had pledged to return to build missions in the Utah Lake region.

But the promised missions never materialized. After the Domínguez-Escalante expedition, Spanish authorities lost interest in the Colorado-Utah region and the people who lived there.

It wouldn't be until after Mexico obtained its independence from Spain in 1821 that a reliable overland route from Santa Fe to California would be established. It came to be known as the Old Spanish Trail.

7

ANTOINE ROBIDOUX, MERCHANT IN THE WILDERNESS

(1828–1844)

I n 1831, it is believed, trader Antoine Robidoux took time during a break in his travels to carve a message in a rock wall just west of today's border between Colorado and Utah.

"Antoine Robidoux passed here 13 November 1837 to establish a trading post at the Green River of Uintah," he wrote in French. Robidoux actually opened the new trading post in the Green River Basin in late 1831, so historians believe that is the year he intended to carve, even though the inscription appears to say 1837.

Robidoux was, in effect, opening a branch store. He already operated a trading post called Fort Uncompahgre at the main ford of the Gunnison River, just west of today's Delta, Colorado. Opened in 1828, it was the first retail operation in western Colorado. It sat at an important crossroads along the North Branch of the Old Spanish Trail, and therefore attracted Ute and other Indians, fur trappers and occasional travelers on the trail between Santa Fe and California.

But like any ambitious merchant, Robidoux was eager to find more business opportunities. There appeared to be more beaver and more trappers congregating around the Green River in Utah's Unintah Basin. So in September 1831, Robidoux applied for and received his second permit from the government of Mexico—which, at the time, claimed most of the Colorado Plateau and regions west to California—to operate a trading post near the Green River.

The second post, variously called Fort Robidoux, Fort Uintah or Fort Winty, was actually located on Uintah Creek north of today's Roosevelt, Utah. But as with Fort Uncompahgre, it was in an area well traveled by Indians and fur trappers.

Unlike most of the mountain men who arrived in the Rocky Mountains and Colorado Plateau to trap and trade, Robidoux wasn't a newcomer to the business when he opened his posts.

Born in 1794 in St. Louis, Missouri, he came from a family of fur traders. His French Canadian father had migrated to St. Louis when it was still under French control, and he owned a fur-trade business there. Antoine and five of his brothers became involved in the fur trade.

In 1824, three years after Mexico won its independence from Spain and began to allow trade with the United States, Antoine and one of his brothers headed west on what would become the Santa Fe Trail from Missouri to New Mexico. Antoine soon moved to Santa Fe and became a prominent citizen of that historic town. He was elected to the Santa Fe City Council

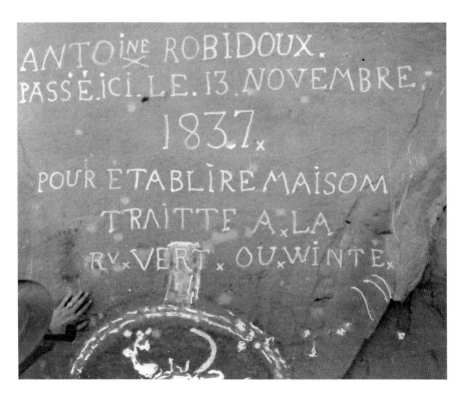

Antoine Robidoux's inscription on a rock wall near the Colorado-Utah border. *Museums of Western Colorado.*

in 1827, and the following year, he married the adopted daughter of the governor of Mexico.

Also in 1828, he received his first trading permit, to operate Fort Uncompahgre, and began to make regular trips north through Taos, New Mexico, and Colorado's San Luis Valley, over the Continental Divide at Cochetopa Pass, then northwest to the Uncompahgre Valley and his trading post on the Gunnison River. Occasionally, he may have used two-wheeled oxcarts to get to the base of Cochetopa, but it was all horses and pack mules beyond that point.

The rock inscription Robidoux chiseled a few years later is in a small canyon along a dirt road about fifteen miles north of Interstate 70. It is well off the beaten path today. But in the early nineteenth century, it *was* the beaten path on the main pack trail between the Uintah Basin and the Gunnison River. Several thousand years of native rock art on a nearby cliff show the route had long been used before Europeans arrived.

Sometime in the 1840s, writer and adventurer Rufus B. Sage encountered Robidoux and his entourage in Taos, headed for the Uintah trading post. Robioux agreed to let Sage accompany them, and Sage described the caravan: "Some eight pack-mules, laden at the rate of two hundred and fifty pounds each, conveyed a quantity of goods; these headed by a guide followed in Indian file, and the remainder of the company mounted on horseback brought up the rear."

It took the caravan six days to reach Fort Uintah from Taos, a distance of roughly four hundred miles. During the trip, the group crossed several large streams, Sage said, including "two principal branches which unite to form the Colorado." He was probably referring to the Gunnison River and the main stem of the Colorado River, which flow together at present-day Grand Junction. They also would have crossed the Green River farther to the north.

Robidoux employed his own trappers, about twenty at each of his forts. They were a "motley collection of Canadian and Mexican engagés and hunters," according to Captain John C. Frémont, who stopped at Robidoux's Uintah Basin trading post in the mid-1840s.

The engagés, or hired employees, were required to sell all the animal furs they trapped to Robidoux at a set price, while the independent or "free trappers" could sell to the highest bidder. But Robidoux paid sufficient prices to attract a number of well-known independent trappers. Among them was Kit Carson, who sold his furs to Robidoux in 1833 and 1838.

In addition to furs and deer hides, Robidoux traded horses, and according to several sources, he occasionally joined in the Indian slave trade that was a significant part of commerce along the Old Spanish Trail.

Despite having exclusive rights through his permits from Mexico, Robidoux faced a number of illegal competitors. Fort Davy Crockett, established in 1836 and named in honor of the man who fell at the Alamo that year, was across Green River in Brown's Park, Colorado. Representatives of the American Fur Company and the British Hudson's Bay Company also intruded on his territory.

It wasn't this competition that destroyed Robidoux's fur business, however. By the 1840s, the entire industry was in decline due to excessive beaver trapping and changes in men's hat fashions. The last major rendezvous for Rocky Mountain trappers and traders was held in 1840.

More importantly, Robidoux apparently lost the trust of the Ute Indians. In September 1844, Utes, responding to an unprovoked attack from Mexican militia, began attacking settlers in New Mexico and Colorado's San Luis Valley. In late September, they fell upon Fort Uncompahgre, killing all but one of the workers, who made his way on foot to Taos. During the same period, they also burned Fort Uintah to the ground.

Robidoux didn't attempt to reopen either trading post. Instead, he retreated to Santa Fe and eventually St. Louis.

In 1845, the governor of New Mexico investigated claims that Antoine Robidoux was selling guns to the Utes and Shoshones, which violated long-standing Mexican law. But the governor died that year, and Robidoux was not formally charged.

That same year, Robidoux became interpreter for General Stephen Watts Kearny while Kearny was in New Mexico. Robidoux continued with Kearny during the war with Mexico, which led to the Colorado Plateau, the entire Southwest and California becoming part of the United States. In December 1846, Robidoux was wounded by a lance thrust to his back during the Battle of San Pasqual.

Robidoux left New Mexico for good shortly afterward. He died in St. Louis in 1860. It would be another two decades before retail operations would be reestablished in most of the territory his trading posts served.

8

OLD SPANISH TRAIL WAS COMMERCIAL HIGHWAY

(1831–1850)

In early May 1848, Lieutenant George Brewerton left the small community of Los Angeles, California, and headed toward Santa Fe, New Mexico, in the company of twenty-seven men led by famed explorer Kit Carson. They followed what Brewerton called "the great Spanish trail," today known as the Old Spanish Trail.

Entering the Mojave Desert, Brewerton said, "Our route for several days lay over a dreary waste, where the eye met the same eternal rock and sand. In fact, the whole country looks more like the crater of an immense volcano than anything else that I can compare it to."

They passed the skeletons of many horses, victims of earlier expeditions across the trail.

Not all of the 1,200 miles of trail were as bleak as that Mojave Desert section. But other sections, in eastern Utah and Colorado, proved even more dangerous. Carson and company made the journey in a little over a month on horseback, with pack mules. They dragged themselves into Taos, New Mexico, in mid-June, nearly starving and with only tatters for clothes, having lost most of their gear and weapons in an ill-fated crossing of the flooding Colorado River near today's Grand Junction, Colorado.

Carson continued to Washington, D.C., with dispatches about the gold strike at Sutter's Mill in central California.

That news helped spark the California gold rush the following year. But almost none of the '49ers used the Old Spanish Trail to reach California. Many went by ship around the horn of South America. Others used the northern route that became known as the Oregon Trail.

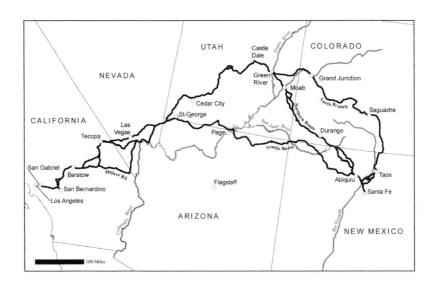

Map of the Old Spanish Trail. *National Park Service, Old Spanish National Historic Trail.*

In fact, by the time Brewerton and Carson traveled the trail together in 1848, the Old Spanish Trail was nearing the end of its days as a commercial pack trail. Its heyday was from 1831 to 1848.

During that time, it became famous among travelers in the West, even if it never gained the notoriety of the Santa Fe Trail, which accommodated wagon traffic between Santa Fe and St. Joseph, Missouri.

Explorer John C. Frémont has sometimes been credited with being the first to use the Spanish Trail name following a journey across parts of the trail in 1844. However, similar names were being used for portions of the trail even before it became widely used commercially.

For instance, Jacob Fowler, who was trapping beaver in Colorado's San Luis Valley in 1822, wrote in his journal on April 5 that he and his small party traveled about ten miles that day, and they camped "a little below the Spanish Road." This was on what would become known as the North Branch of the Old Spanish Trail, and the camp was along the Rio Grande near today's Del Norte, Colorado.

The North Branch went through Taos, the San Luis Valley, over Cochetopa Pass to the Gunnison and Uncompahgre Valleys of Colorado, then on through today's Grand Junction to Green River, Utah.

The southern or Main Branch of the trail headed west from Santa Fe to Abiquiu, New Mexico, then north into Colorado near today's Durango.

Then it headed northwest into Utah, crossing the Colorado River near Moab, Utah, then linking up with the North Branch at Green River.

There were variations from each of these routes, and that has been part of the difficulty in defining the trail.

"To no one person can be given the honor of opening this historic travel way," wrote LeRoy and Ann Hafen in their seminal book about the trail. "This was a folk trail, mastered segment by segment through many years and by many forces."

Those forces included Indians of various tribes who lived along the route, but especially the Utes. There were Spanish explorers such as Juan Rivera, friars Domínguez and Escalante, and New Mexico governor Juan Bautista de Anza, who traveled part of the trail in 1779. It also included numerous unknown Mexican traders and many American fur trappers.

Trader Antonio Armijo is credited with making the first commercial expedition from Santa Fe to Los Angeles in 1829, but he used a route that journeyed south of the Main Branch of the Old Spanish Trail.

In 1831, American trappers William Wolfskill and George C. Yount and a small party of fellow trappers are believed to be the first to travel the entire length of the Main Branch of the Old Spanish Trail from Santa Fe to California.

During its prime, the trail was used strictly for horses, pack mules and men on foot. As the Hafens put it, "During decades of use, no wagons ever traversed the complete course of the Old Spanish Trail."

Eventually, however, wagons did make their way over parts of the trail. Captain John Gunnison is believed to have been the first to use wagons in what's now western Colorado. In 1853, he led an expedition with twenty wagons over the North Branch of the Old Spanish Trail, across western Colorado and into Utah. Gunnison was killed later that year by Indians in western Utah. His second-in-command, Lieutenant E.G. Beckwith, completed the expedition, searching for a railroad route to the Pacific, and wrote a lengthy report of the trip.

Beckwith made it clear that it was no easy task getting wagons over the horse trail. Arriving in the Uncompahgre Valley after a particularly rough day, he wrote that the group was forced to provide "relief for our jaded animals, which had been eleven hours in making fourteen miles."

Five years later, the U.S. Army made wagon travel easier when it constructed the Salt Lake Wagon Road between Salt Lake City and Fort Union in northeastern New Mexico. Most of that route followed the North Branch of the Old Spanish Trail, and parts of it are still visible in the form

of deeply eroded wagon ruts near U.S. Highway 50 between Grand Junction and Delta, Colorado.

The Old Spanish Trail, however, grew to prominence before any wagon rolled along its route. The reason was simple economics. Woolen goods produced in the sheep-heavy regions of New Mexico could be traded for goods on the hoof. Horses and mules that could be purchased for a couple of serapes in California sold for many times that in Santa Fe and even more than that if they were taken all the way to Missouri to be sold to immigrants heading northwest on the Oregon Trail.

The men who conducted this commerce were a strange blend of well-dressed Mexican traders and poorly outfitted peasant herders. Brewerton offered one of the best descriptions of such a caravan that he and Carson passed on the trail: "This caravan consisted of some two or three hundred Mexican traders who go once a year to the Californian coast." The caravan they passed was headed home to Santa Fe. It had nearly a thousand horses, mules and a few donkeys, and it created problems for other travelers because the livestock ate up nearly all of the meager grass in its path.

Brewerton was unimpressed with the weapons displayed by the members of the caravan. "Many of these people had no fire-arms, being only provided with the short bows and arrows usually carried by New Mexican herdsmen," he wrote. "Others were armed with old English muskets, condemned long ago as unserviceable." Many also had rusty sabers tied onto their horses and mules.

Such weapons were apparently sufficient, so long as the merchants paid Ute leaders for their passage. There are few reports of thefts from or attacks on the caravans themselves.

It was a long, often dry and sometimes freezing-cold journey. But there were profits to be made by adventurous and determined merchants along the Old Spanish Trail.

III

RIVERS
OF OPPORTUNITY

9

JOHN WESLEY POWELL ALLY JACK SUMNER BECAME A BITTER CRITIC

(1869–1905)

John Wesley Powell and Jack Sumner were friends and colleagues when they began their famous 1869 trip down the Green and Colorado Rivers, the first river expedition to travel the entire length of the Grand Canyon.

But as Powell's fame spread in subsequent years through the books he wrote and important national positions he held, Sumner became increasingly bitter. By the time Powell died in 1902, Sumner was eager to belittle his former boss's reputation. He publicly accused Powell of poor leadership, of refusing to give credit to his crew and of declining to share money that Powell had supposedly received for the expedition.

A few years later, Sumner even accused Powell of being indirectly responsible for the deaths of three men who left the expedition just before it was completed.

Sumner's churlish accusations did little to diminish Powell's stature, however. In addition to the river expeditions, Powell had provided detailed ethnographic descriptions of many Indian tribes of the Colorado Plateau. He also became the second head of the U.S. Geological Survey, and he wrote an important book about the arid regions of the West. In fact, Powell did more temporary damage to his own reputation than Sumner did. Powell publicly disputed the nineteenth-century belief that the arid lands of the West were suitable for massive settlement and large-scale agricultural development. Only decades later did his views become widely accepted.

John Wesley Powell with an Ute Indian near the Green River, circa 1871. *Museums of Western Colorado.*

As for the 1869 expedition, Sumner was second in command, but it was Powell's imagination and determination that fueled one of the most remarkable trips in the history of the West.

Most of the West had been explored by 1869, and a variety of explorers—from Spanish to American—had examined the edges of the canyon country. Still, as Wallace Stegner wrote, most of the lands in the canyon region of the Colorado Plateau "were a tantalizing blank marked, in a cartographer's neat lettering, 'Unexplored.'"

Powell, a one-armed Civil War veteran and self-taught scientist from the Midwest, decided he would lead an expedition through those unexplored lands. He won approval from Congress for his endeavor but no funding. He obtained money from a few scientific and academic organizations in Illinois and tapped his own meager resources.

Over two years, he visited Colorado and Wyoming and began to put together his expedition with family members and young adventurers. Sumner, a trapper who operated a trading post at Hot Sulphur Springs in Colorado's northern mountains, enthusiastically joined. Powell also ordered four wooden boats made to his specifications by builders in Chicago. They were not well suited for the rivers they were to descend, but no better boats existed then.

The four boats were launched at Green River, Wyoming, on May 24, 1869, with ten men aboard. They included Powell and Sumner; Powell's brother, Walter; O.G. Howland and his brother, Seneca; George Bradley; William Dunn; Frank Goodman; William Hawkins and Andrew Hall.

The crew members were exuberant about catapulting through the first rapids of the Green River. "[N]othing is more exhilarating [*sic*]…as a breaker dashes over us, as we shoot out from one side or the other, after having run the fall, one feels like hurrahing," wrote O.G. Howland in a letter sent to the *Rocky Mountain News* during a stop near the Uintah Indian Agency.

By the end of August, however, as they struggled to complete their journey, the sentiment was much different. As Sumner put it, referring to the canyon country: "I never want to see it again."

The first problem occurred on June 8. One of the boats, called the *No Name*, failed to make it to shore ahead of falls on the Green River. Powell, watching from the shore, said he saw the boat "strike a rock" then partially fill with water. The boat was swept into a large boulder. "She is broken quite in two and the men are thrown into the river," Powell wrote.

The three occupants, the Howland brothers and Frank Goodman, survived but were left on an island and a giant boulder in the river. Jack Sumner immediately jumped in another boat and raced to rescue the men, getting all three safely into his boat and back to shore. Powell wrote glowingly of Sumner's expertise during the rescue.

While the men survived, valuable supplies did not. Some two thousand pounds of food, plus clothing and equipment, were lost. A portion of the food was replaced when the expedition stopped at the mouth of the Uintah River, in northern Utah, and Powell hiked to the Uintah Indian Agency several miles away.

Goodman, an Englishman who'd had enough after the wreck of the *No Name*, joined Powell on the hike and refused to return to the boats. Powell hired Ute Indians to pack new supplies to the crew. But the expedition would have much shorter rations for the remainder of the trip.

The *No Name* wreck was far from the only mishap. On June 16, winds whipped up sparks from a campfire and set willows ablaze. The crew lost more supplies as they scrambled to their boats and the safety of the river.

Powell, climbing rocks to take scientific readings, got caught on a ledge from which he couldn't get down. George Bradley rescued him, using his long johns as a rope.

There would be rain, excessive heat and swarms of mosquitoes. They would see miles and miles of spectacular canyon country and splash through scores of difficult rapids. No other boats were lost, however.

The greatest disaster occurred on August 28, when the Howland brothers and William Dunn decided to walk to Mormon settlements at the Virgin River. They were never seen alive again. Bodies believed to be theirs were found a month later. They had reportedly been killed by a Shivwit band of Paiute Indians.

If they had stayed with the boats, they would have made it to the Virgin River two days later, with the rest of the group, and would have been fed by Mormon farmers.

In one hundred days, the expedition had conquered roughly one thousand miles of mostly untraveled portions of two great rivers. Some

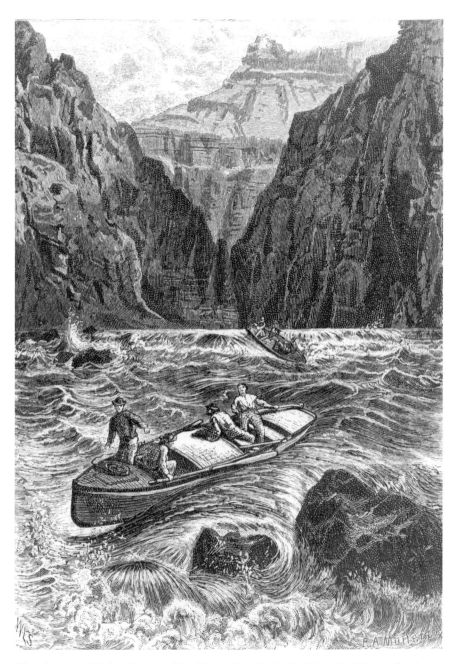

"Running a rapid," drawing from John Wesley Powell's book. *National Park Service, Grand Canyon National Park, The Powell Expedition Photo Gallery.*

called it the last great exploration of the continental United States. But it had come at great cost.

When Powell died in 1902, Sumner decided it was time to tell his version of the expedition. He sent a letter to the *Denver Post*, and it was published on October 13, 1902.

Sumner attacked Powell for not sharing with Sumner and other expedition members the $50,000 that Sumner believed Powell had received from Congress for the trip. He criticized Powell for failing to give adequate credit to his companions. And he charged Powell with "stupidity" for not acquiring more supplies after the *No Name* wreck.

Wallace Stegner debunked these claims in a 1949 *Colorado History* magazine article. The only cash for the expedition came from the pockets of Powell and Sumner and from organizations in Illinois, Stegner's research determined. And, while Powell didn't heap praises on his companions, he did acknowledge their efforts in letters and official reports.

Sumner leveled his most serious charge against Powell several years later, but it didn't become widely known until after his death, when letters he wrote to fellow river traveler Robert Brewster Stanton were published in a book by Stanton.

Sumner described a series of verbal squabbles between Powell, O.G. Howland and Dunn that culminated when Powell ordered Dunn to leave the expedition because he had been careless with scientific instruments. Sumner came to Dunn's defense, and Powell backed down, Sumner wrote. But the anger simmered, so that by August 28, Dunn and the Howlands were eager to leave when a path out presented itself.

However, that's not the story Sumner and others had told earlier. Sumner, Powell and George Bradley all kept journals during the 1869 expedition. None of them recorded a dispute between Powell and other expedition members.

In his journal entry for August 28, Sumner wrote only that the Howland brothers and Dunn "decided to abandon the outfit and try to reach the settlement in the head of the Virgin river."

Powell's journal entry was more succinct: "August 28—Boys left us. Ran rapid…Make camp on left bank. Camp 44." In his journal, Bradley wrote: "Three men refused to go farther.…They left us with good feelings though we deeply regret their loss for they are as fine fellows as I ever had the good fortune to meet."

Sumner spent most of the last twenty-five years of his life in Grand Junction, Colorado, although he died in 1907 in Vernal, Utah. He owned considerable real estate in Grand Junction and had mining claims in Utah.

It's clear Sumner's anger had been simmering for a long time. In his 1869 journal, upon arriving in Yuma, Arizona, he wrote, "After two years of hard work and exploration of the Colorado and its tributaries I find myself pennyless [*sic*] and disgusted with the whole thing."

MINING AMBITIONS CREATED DOLORES RIVER'S HANGING FLUME

(1883—1904)

Water flows uphill to money, according to an old adage in the West. In the Dolores River Canyon of western Colorado in the late nineteenth century, water didn't actually flow uphill. But it did flow in an unlikely place—on the side of a rock cliff hundreds of feet above the river itself. Investors believed great wealth could be obtained by mining for gold downstream on the river, but they needed massive amounts of water for the task.

Over the course of two years, the Montrose Placer Mining Company constructed seven miles of wooden flume attached by steel bolts and wooden supports to the sandstone wall of Dolores Canyon. Another three miles of canals and ditches carried the water from the San Miguel River, a tributary of the Dolores, to the wooden flume. Each day, the flume carried millions of gallons of water to a placer mining claim, where the water was to be utilized for hydraulic mining.

Placer mining involves taking rocks, sand and gravel found on the surface near riverbeds and washing it through sluice boxes so that heavy gold is left behind. Hydraulic mining is an industrial variation on that technique in which water is shot through a nozzle at high pressure onto the face of a cliff or gravel deposit, washing away tons of gravel, rock and dirt that can then be run through large-scale sluicing systems.

The *Engineering and Mining Journal* touted the Dolores project in May 1890: "This work will show how easy it is, when backed up by enterprising capital, to bring water from and to points which were always thought to be

inaccessible....The total cost will be about $75,000 when finished, and it is expected to be completed within a few months."

The esteemed industry publication was wrong on several counts.

First, according to reports from the principals involved, the actual cost was between $165,000 and $175,000. Additionally, it was more than a year before the flume was completed, or at least partially completed. The owners had planned to construct it another three miles down the canyon to reach all of the company's five mining claims along the Dolores River. Instead, it only reached the first, or southernmost, of those claims and never went farther.

But the most significant error in the *Engineering and Mining Journal* article was suggesting the project would be *easy*.

Although enterprising capital was, indeed, found—on several occasions—to pay for construction of the flume and other aspects of the project, the companies involved were constantly in financial difficulty. The gold recovered proved too meager to handle the debt. The flume only operated as intended for one year, 1891, and by 1904, it was abandoned.

Interest in mining along the Dolores River began not long after the Ute Indians were forcibly removed from most of western Colorado in 1881.

The five mining claims involved with the flume were staked out along the Dolores River from 1883 through 1885 by the Lone Tree Mining Company, a group of Salt Lake City investors. The company began conventional placer mining on one of the five claims along the Dolores River, using limited water from a nearby creek.

In 1887, Lone Tree sold the claims to the Montrose Placer Mining Company, which was made up of investors from East St. Louis, Illinois. The company was managed by Nathaniel P. Turner, a somewhat mysterious figure who had reportedly gained experience in hydraulic mining in California. He decided hydraulic mining would work in Colorado, and a flume could be constructed similar to some used in California.

Construction of the flume itself was anything but easy. Clear pine was logged and sawed in Utah's La Sal Mountains, some forty miles away, rather than the closer Uncompahgre Plateau, where the wood wasn't as good and the access more difficult.

At least eighteen trails or wagon roads were built to carry materials to different parts of the Dolores River Canyon, where they could be lowered by ropes and trolleys to the workers below. Workers were suspended by ropes to mark the grade the flume was to follow and were suspended again while drilling holes for the one-and-a-half-inch bolts that were hammered eighteen

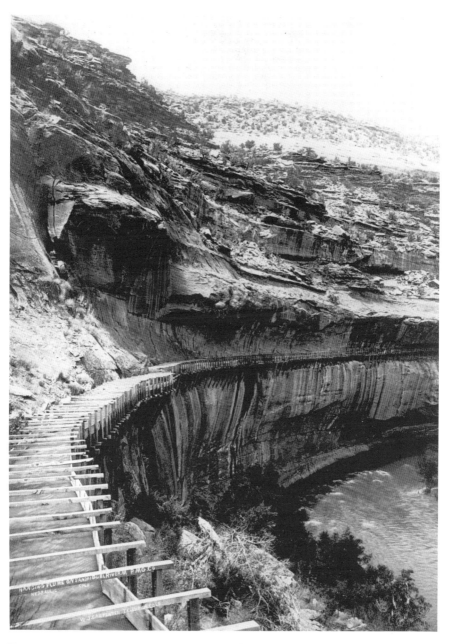

Hanging flume above the Dolores River in western Colorado, circa 1891. *Museums of Western Colorado.*

inches into the rock to anchor the steel holding the wood of the flume. Later, the workers used a cantilevered derrick attached to the end of the previously constructed sections of flume to build each new section.

A crew of a dozen men could complete approximately 860 feet of flume per day, according to the *Engineering and Mining Journal*. They clearly didn't work at that pace for a full year, however, or much more of the flume would have been completed. However, despite the dangers and technical difficulties, construction moved steadily, with no reports of serious injury.

Turner received accolades for the design and work on the flume, and he was an enthusiastic booster of his project.

In the *Grand Junction News* in May 1891, shortly after the flume was completed to the first of the mining claims, Turner said that "washing has been in progress for the past 10 days and everything looks promising for a speedy and profitable return to the company."

But, alas, Turner's prediction was no more accurate than those of the *Engineering and Mining Journal*. The gold recovered from the hydraulic washing proved to be too fine to be collected in appreciable amounts, and it's not clear how long the washing continued. A year later, the U.S. General Land Office demanded money that was still owed for one of the company's five mining claims. Apparently, Lone Tree Mining had never made the final payment on the claim before it sold the claims to Turner's firm.

The Montrose Placer Mining Company was unable to pay, and Turner left the company in disgrace. But the following year, 1893, the claims and flume were sold at a sheriff's sale, and Turner reappeared to purchase them, having formed the Vixen Alluvial Gold Mining Company.

It was another four years before any action occurred with the claims, however. By then, Turner had sold the company, but he continued to act as its manager. In 1897, Vixen obtained $21,000 in additional financing from a Montrose, Colorado, man named Frank Catlin. The company apparently intended to complete the final three miles of the flume and begin hydraulic mining on the remaining four claims. But that never occurred.

The entire system was lost in a court judgment in 1899, then sold again in 1900, this time to a company called the Montrose Mining Company, whose investors were from the Denver area.

The new company reported that it worked the claims for four weeks in 1903, then quit. The property was sold one more time, but there is no evidence that any work on the mining claims was conducted after 1903. Before long, settlers and ranchers in the area began scavenging wood from the easily accessible portions of the flume.

Hanging flume above the Dolores River as it appeared in 2016. *Photo by the author.*

A century after the flume was abandoned, an effort began to preserve it. The nonprofit Interpretive Association of Western Colorado, working with the U.S. Bureau of Land Management and John Hendricks of Gateway Canyons Resort, contracted for studies of the flume's construction and its history. In 2012, forty-eight feet of the flume were rebuilt using lumber and construction techniques as similar as possible to those used in 1890 and 1891.

The flume is listed in the National Register of Historic Places and is the longest historic structure in Colorado.

11

ROUGH WATER AHEAD: STEAMBOATS AND WILD RIVERS

(1901–1902)

T he excitement was palpable when the steamboat *Undine* launched at Green River, Utah, in November 1901. Newspapers at the time predicted a new river commerce tying together the communities along the Green and Colorado Rivers more closely.

Within a year, there was expected to be a fleet of riverboats "with ore and fruit barges in tow," carrying mining and agricultural produce from the river communities.

"The new water transportation company expects to handle everything in the way of freight down the [Green] river and up [the Colorado River] to the La Salle country" near Moab, Utah, the *Emory County Progress* newspaper of Castle Dale, Utah, reported on November 21, 1901. It would also haul "back to Green River Station all minerals, oils, fruit etc., that may be produced along the route."

The *Undine*'s destination was Moab, more than 180 river miles away from Green River, and the manager of the new riverboat line expected that within a few years the line would have "a most lucrative patronage."

But that lucrative business never materialized. The *Undine* made one successful trip to Moab and back. On its second trip in 1902, the boat capsized on the Colorado River just below Moab. The captain and two crew members were fortunate to survive.

Like others before them, the Denver-based entrepreneurs who launched the *Undine* saw the Green and Colorado Rivers as potential transportation highways, much like the rivers of the East and Midwest. Even the Missouri

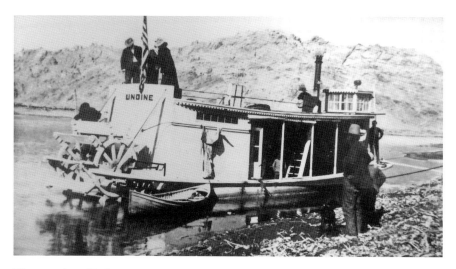

The steamboat *Undine* on the Colorado River near Moab, Utah, November 1901. *Museum of Moab.*

and Platte Rivers on the eastern side of the Rocky Mountains accommodated steamboats, although it wasn't always easy.

But unlike those other river systems, the Colorado and its tributaries would never prove viable for commercial transportation. The rugged river canyons of the Colorado Plateau proved too daunting, even for the most determined enterprises.

Still, the *Undine*'s owners weren't the first to attempt to navigate these waters.

William Ashley and seven trappers who worked with Ashley's Rocky Mountain Fur Company made the first documented attempt to float a vessel down a portion of the Green River in 1825. They descended the upper part of the Green in bull boats—round saucers of buffalo hide stretched over willow frames with very little steering capacity.

Despite encountering several of the river's famous rapids, such as those in the canyon below the Gates of Lodore, Ashley and his men succeeded in floating and portaging a significant portion of the Green. They traveled from Flaming Gorge on the Utah-Wyoming line to Split Mountain near present-day Jensen, Utah.

Prior to the arrival of Europeans, it's likely Indians attempted to navigate parts of the Green and Colorado Rivers. Indians of various tribes had long visited or lived in places where there was reasonably easy access to the rivers. Several native groups cultivated plants with irrigation

water they diverted from the waterways. Even so, when Americans arrived, natives sought to dissuade them from attempting to put boats on the river.

In 1849, William Manly decided to abandon the trail overland to the California gold fields, believing it would be faster and easier to float the Green and Colorado Rivers to California. With a half-dozen men, he floated a portion of the Upper Green River as far south as the White River using homemade rafts and poorly navigable dugout canoes. Somewhere near Jensen, they met the famed Ute chief Walkara.

Using sign language, Walkara sought to convince Manly that continuing on the river was too dangerous. During a visit in Walkara's lodge, Manly said, "He then made signs of death to show us that it was a fatal place," referring to the river below where they camped. Manly and his men heeded Walkara's warning, acquired some horses from him and headed overland. They succeeded in reaching California, although they nearly died in Death Valley.

Major John Wesley Powell received similar warnings from the Utes as he and his crew prepared to enter the first treacherous canyons of the Green River during their famous 1869 expedition.

"The Indians say, 'Water heap catch 'em,'" Powell wrote. But Powell and his men ignored the warning and eventually made it all the way down both the Green and Colorado Rivers—and through the Grand Canyon.

A dozen years before Powell's trip, another expedition attempted to travel *up* the Colorado River from its mouth in the Gulf of California. The *Explorer*, a U.S. Army sternwheeler under the command of Lieutenant Joseph Ives, launched from the river's mouth on December 31, 1856, headed upstream to Fort Yuma and beyond.

Sixty-four days later, the steamboat arrived at the head of the canyon where Hoover Dam now sits. After an unsuccessful attempt to proceed farther up the canyon, Ives and his crew turned back downstream.

There were other attempts to traverse the river both upstream and downstream. In the 1890s, two small steamboats attempted the Green River–to–Moab run. Neither vessel made it all the way to Moab and back, and the efforts to make steamboat runs on those parts of the two rivers were abandoned until the *Undine*'s journeys.

In 1889 and 1890, Robert Brewster Stanton made two trips on parts of the Green and Colorado Rivers in wooden rowboats as he surveyed for a railroad line to the Pacific through the river canyons. Although two members of the party drowned *before* Stanton assumed command of the venture and

the survey expedition proceeded in fits and starts, Stanton did complete the survey. But he was unsuccessful in persuading investors to commit enough money to the railroad venture, and the rail line was not built.

The section of the Green and Colorado Rivers between the towns of Green River and Moab is not the most dangerous part of the river system. During the 1920s, a paddleboat operated in parts of these waters to haul equipment to oil drillers working along the Colorado River. In the 1940s, a man named Ace Turner operated tourist trips on a propeller-driven airboat between Moab and Green River. In modern times, motorized pleasure boats have made that run in a convoy on Memorial Day weekend.

Even so, anyone who has visited these stretches of the Green and Colorado Rivers knows they are swift and rocky enough to make them far different from the flat water of other rivers. During high water in the spring, the swift-running streams make navigation problematic to say the least. In low water, protruding rocks and gravel bars just below the surface create a different set of problems.

The dream of the *Undine*'s owners to have a fleet of riverboats towing freight barges was doused when the *Undine* capsized in the Colorado River eight miles below Moab in May 1902. The wreck occurred as crew members attempted to pull the boat around a small rapid using ropes and pulleys, the *Salt Lake Telegram* reported on May 23, 1902.

The captain was thrown into the water and carried a mile and a half downstream before he could reach shore. His two crew members climbed on top of the overturned *Undine*, which floated upside down for four miles before washing up on a gravel bar in the middle of the river. They had to be rescued by rowboat, said the *Telegram*.

Nearly all of the steamboat's machinery was lost in the wreck, and the hull was severely damaged. The *Undine* was simply left on the gravel bar in the river. By midsummer, the only news about the *Undine* was that creditors were attempting to get money from the owners of the riverboat to pay their debts.

"This will probably end the proposed [steamboat] line," the Salt Lake City newspaper correctly predicted.

12

DAMS, DIVERSIONS AND IRRIGATION SYSTEMS

(1902–1960s)

When World War I erupted in August 1914, it threatened to halt a long-sought irrigation project half a world away in the agricultural lands of the Grand Valley that surround Grand Junction, Colorado.

Engineers with the U.S. Reclamation Service had chosen a roller crest design for the dam on the Colorado River that would regulate the irrigation project. But the patent for the roller crest equipment was held by a German company, and the company's factories were enlisted in the war effort.

The people in the Grand Valley who supported the construction of the dam and the accompanying Government Highline Canal that would carry irrigation water to thousands of acres of high desert in the Grand Valley were familiar with such hurdles. They had already dealt with opposition to the project from Denver; foot-dragging in Washington, D.C.; disputes with other local irrigators; and more.

So, working with the government engineers, they found a firm in Pittsburgh, Pennsylvania, Ritter-Conley Manufacturing, that was able to build the steel rollers using the German design.

A roller crest dam employs large steel rollers that can be raised and lowered to maintain a constant level in the river behind the dam, even as it releases water into the irrigation canal. The system ensures enough water for the canal during times of low water but prevents flooding at high water.

The giant steel rollers were delivered by railroad to the dam site just east of Palisade, Colorado, in the spring of 1915. They were installed in the concrete structure of the new dam in time for the official dedication

ceremony of the roller dam on June 29, 1915. Water began flowing into the Highline Canal a few days later.

Other than for adventure and tourism, the Colorado River and its tributaries never became the sort of commercial transportation corridors that people of the nineteenth century had envisioned. But by the early twentieth century, a new sort of commercial enterprise was being developed for the Colorado River system—multiple dams to supply irrigation water and, eventually, hydroelectricity, flood control and recreation.

The Reclamation Act of 1902 created the U.S. Reclamation Service, which eventually became the Bureau of Reclamation. The same legislation also authorized multiple dam projects in sixteen states, including $31.5 million for the Grand Valley Diversion Dam, as the roller dam was officially called, along with the Highline Canal. But it would take another decade before work on the project actually commenced.

The projects authorized in the original Reclamation Act were relatively small by today's standards. The roller dam on the Colorado River east of Palisade is roughly thirty feet high, not counting work towers spaced across the dam. But dams of entirely different scale and construction were to follow a few decades later.

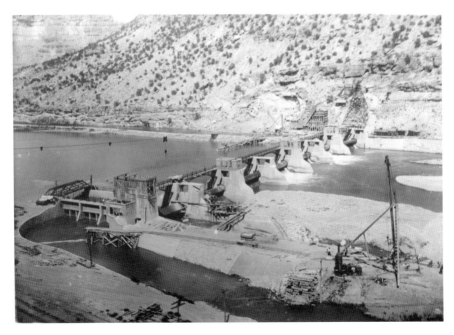

Grand Valley Roller Dam under construction, circa 1915. *Museums of Western Colorado.*

Hoover Dam, on the lower Colorado River, was the beginning. Construction started in 1932, in the midst of the Great Depression, but planning had actually begun decades earlier in response to massive floods on the Colorado.

"Overstating the significance of Hoover is almost impossible, so thoroughly did the dam surpass…everything that had come before," wrote author Kevin Fedarko in his book *The Emerald Mile*. At 726 feet tall, the dam was double the height of any dam then in existence. Lake Mead, the reservoir created by the dam, was the largest man-made lake in the world at the time. Furthermore, to build the huge dam, engineers had to develop entirely new design and construction methods.

The dam was completed in 1935, and it opened the floodgates, as it were, for numerous other projects on the Colorado River system.

The most famous of these—and the most politically charged—was Glen Canyon Dam (and Lake Powell behind it). Constructed in the late 1950s and early 1960s, the dam was only built after a contentious negotiation between dam supporters such as House Interior Committee chairman Wayne Aspinall of Palisade, Colorado, and David Brower of the Sierra Club in California.

The same Colorado River Storage Project Act of 1956 that authorized Lake Powell also provided for the construction of other large dams and reservoirs on the Colorado and its tributaries, such as Flaming Gorge on the Green River near the Utah-Wyoming border and Blue Mesa Reservoir on the Gunnison River east of Montrose, Colorado.

But such massive projects were not envisioned when horse-drawn scrapers and early steam shovels were clearing the pathways of the Highline Canal and establishing the concrete foundations of the roller dam.

There were other irrigation projects in this valley that predated the Grand Valley Project. But the lengthy Highline Canal was designed to carry water farther west than any of the other projects and to supply more acres with irrigation water. It was also more dependable than existing projects because of its ability to provide irrigation at high water or low.

The project was finally given the federal go-ahead in 1912, and the first work began on July 1, 1913. Most of it was completed within two years.

There were problems during construction, as newspaper accounts indicate. One, from January 22, 1915, reported that a "race battle" was fought among workers digging the Highline Canal. The article in Grand Junction's *Daily Sentinel* revealed the racial animosity was "between Americans on one side and Greeks and Italians on the other." The

Horse teams digging the Highline Canal near Palisade, Colorado, circa 1915. *Palisade Historical Society, Danny Williamson collection.*

animosity resulted "in a free-for-all combat in which participants emerged with sundry bruises, cuts and occasional dislocations of fingers and knuckles," said the *Sentinel*.

It was only a minor disruption, and work continued, apparently without incident, from that day onward.

There was also a dispute with the nearby Orchard Mesa Irrigation District, which feared that the roller dam would harm its own small diversion dam and canal on the opposite side of the Colorado River from the Highline Canal.

However, an agreement was reached, and key features of the Orchard Mesa system, including a pumping station outside of Palisade, were incorporated into the Grand Valley Project.

Although the Bureau of Reclamation built and owns the Grand Valley Project, the Grand Valley Water Users Association operates and maintains it.

A century after the dam's completion, the massive steel rollers manufactured in Pittsburgh in 1915 continue to operate on the same original gear system with the original Westinghouse electric motors used to raise and lower the rollers. There have been minor repairs, but the roller crest design has proved its worth many times over.

IV

RANCHERS AND HOMESTEADERS ARRIVE

HOLE-IN-THE-ROCK EXPEDITION OVERCAME UNIMAGINABLE OBSTACLES

(1879—1880)

One of the Mormon pioneers who drove his team and wagon to the edge of the Hole-in-the-Rock admitted he was "scared to death" when he looked through the narrow notch in the sandstone wall and spied the Colorado River some 1,200 feet below.

So were the horses hitched to the front of his wagon. They had no intention of stepping onto the forty-five-degree slope of slick rock that confronted them. Consequently, other members of the expedition had to push the wagon from the back, forcing it into the rumps of the horses and pushing them over the edge.

Down they plunged, sliding and skidding on the rock. The wheels of the wagons were locked with chains and logs. Men behind the wagons hauled on ropes to slow the descent. Some of the animals fell to their knees, but none died. Finally, livestock and wagons slid to a halt in a sandy flat spot about three hundred feet from the top.

Remarkably, all of the eighty-three wagons in the expedition made the same slide with no loss of life, human or animal.

One wagon, belonging to Joseph Stanford Smith and his wife, Arabella, plunged through the Hole without other men to help hold the wagon back. Joseph drove while Arabella held the reins of a horse tied to the back of the wagon to restrain it. Both the horse and Arabella ended up on their knees skidding on the slick rock. When Joseph managed to halt the wagon on the sandy flat spot, he turned and saw his bedraggled wife with a bloody leg.

He hurried back to her and asked, "Is your leg broken?"

Hole-in-the-Rock, Utah, with the Colorado River in the background, circa 1942. *San Juan County, Utah, Historical Society.*

Angrily, Arabella responded, "Does that feel like it's broken?" as she kicked her husband in the shin.

The Church of Jesus Christ of Latter-day Saints—the Mormons—determined to settle the San Juan River country of southeastern Utah in 1877. Non-Mormons, such as miners, cattlemen and outlaws, were moving into the region, and the church wanted its members to settle and assert control.

However, when Brigham Young died in August 1877, the San Juan Mission, as it was officially called, was delayed. The official call for church members to join the San Juan Mission didn't occur until late December 1878 in Parowan, Utah, north of Cedar City, Utah.

The journey was expected to last six weeks. Instead, it took nearly six months.

Wagon trains on the Oregon Trail from Missouri to the West Coast "traveled half the continent in less time than it took these Saints to cross the corner of one state," wrote historian David Lavender, who grew up herding cattle in the region near the San Juan River.

And none of those other caravans faced obstacles like those the Hole-in-the-Rock Expedition overcame to cross a little more than two hundred miles of southern Utah, he added.

It took nearly six weeks for Welsh-Mormon miners to blast the rock and sufficiently widen the notch at Hole-in-the-Rock for a wagon and team

to slip through. The miners also altered a fifty-foot cliff face at the start of the notch to create the three-hundred-foot slick-rock passage that the wagons descended.

After surviving the Hole-in-the-Rock slide, wagons still had nearly one thousand feet of mountain to descend to reach the Colorado River. First, there was a fifty-foot-long path chiseled into the side of the cliff called Uncle Ben's Dugway, named after Benjamin Perkins, who designed it. It was half dug into the sandstone rock and half cantilevered out over the cliff face on a shelf supported by logs fitted into holes drilled in the rock face.

Past the dugway, the trail was easier for a while. When they reached the bottom, the wagons and teams crossed the Colorado River on a ferry that could handle two outfits at a time. Cattle and saddle horses had to swim the river.

Before this difficult route was chosen, several scouting parties were sent to examine possible paths to the San Juan country. One went south through northern Arizona, crossed the Colorado River at Lee's Ferry and headed northeast toward the San Juan. But that party found angry Navajo Indians and little grass and water for a large expedition.

The Old Spanish Trail was a possibility, running northeast from Cedar City, then east over the San Rafael Swell and finally south toward the San Juan. But at more than 450 miles, that route was considered too long.

One scouting party took the most direct route, from Cedar City to Escalante, Utah, then southeast to the Colorado River. The scouts found a way down to the river and across it, then trekked far enough over rugged country that they could see the San Juan River. In late summer 1879, they reported that the route appeared difficult but doable. Based on their report, mission leader Silas Smith chose this route, sending wheeled wagons where none had gone before.

Families and wagons began moving eastward in small groups in October 1879, mostly from the communities around Cedar City. By early November, most had gathered at a site called Forty-Mile Spring, east of Escalante, Utah. They had supplies to last for six weeks, as well as cattle, horses and personal possessions.

By mid-December, eighty-three wagons and roughly 260 people were in two camps, one at Fifty-Mile Spring, ten miles east of the earlier camp, and one at the edge of the Hole-in-the-Rock. Extra supplies arrived infrequently from Escalante and St. George, Utah.

The descent through the Hole-in-the-Rock, over Uncle Ben's Dugway and the crossing of the Colorado River were accomplished at the end of January

1880. It would take another two and a half months for the expedition to reach what became Bluff, Utah, in the San Juan River Valley, a distance of little more than sixty miles as the crow flies.

First, they had to construct another dugway up a 250-foot-high escarpment. A few miles beyond that, another ascent, up Cottonwood Hill, required seven teams of horses or oxen for each wagon because it was so steep.

New roads had to be constructed in, or carved out of, rock, across Gray Mesa, Comb Ridge and Butler Wash before the expedition members finally arrived in the area that they called Bluff City in April 1880.

The journey was a difficult experience, but expedition members didn't huddle in misery. There were fiddlers and dances under the stars when the weather permitted. Three babies were born on the journey, one during a blizzard.

In coming years, settlers found it tough to irrigate and raise crops along the constantly flooding or nearly dry San Juan River. Many switched to raising cattle and sheep. Others moved north to help found the communities of Blanding and Monticello, Utah.

The fact that they survived the trip and completed the church's mission call was a testament to their faith and perseverance, noted Vern Howell of Loma, Colorado, whose great-grandfather, Jens Nielsen, was one of the leaders of the Hole-in-the-Rock expedition.

"They had amazing tenacity," Howell said. "Jens Nielsen called it 'stick-to-it-ness.'"

DEATH ON THE RANGE: THE KILLINGS OF CHARLES SIEBER AND JOE HARRIS

(1902—1909)

T housands of head of cattle were trailed into western Colorado in the 1880s, and conflict followed cattle.

Although river bottoms in western Colorado and eastern Utah sustained irrigated agriculture, much of the landscape of the Colorado Plateau—the canyons, mesas and mountains—accommodated only livestock grazing. Initially, cattle were the dominant livestock. Large ranches began to spring up in the region, especially in western Colorado. And many a small rancher got his start with cattle pilfered from the larger ranches. But stolen cattle provoked confrontations.

One of the largest early cattle operations in western Colorado was owned and managed by a German immigrant named Charles R. Sieber. He also owned a home in Grand Junction, Colorado, but he ran his cattle on Glade Park and Piñon Mesa, some thirty-five miles to the southwest and roughly three thousand feet higher in elevation than Grand Junction. About 1900, the Sieber Cattle Company and its S Cross Ranch reportedly ran as many as fifteen thousand head of cattle on private land and public range, and family history suggests that number may have reached as high as thirty thousand.

Sieber's life ended in August 1902 when he had a run-in with a former employee and small-ranch operator name Joe Harris. Harris was initially convicted of manslaughter for Sieber's death, but he appealed, and the Colorado Supreme Court ordered a second trial. This time, Harris was acquitted, arguing he shot Sieber in self-defense.

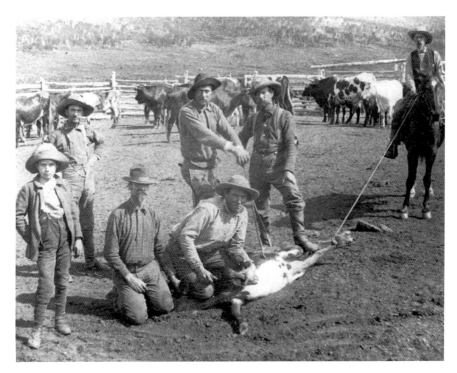

Cowboys branding calves at the Sieber ranch southwest of Grand Junction, Colorado, circa 1890s. *Museums of Western Colorado.*

In a strange twist of fate, Harris was shot and killed seven years later in another dispute over cattle. And the man who shot him went free because he, too, claimed he killed only in self-defense.

Charles Sieber was born near Breslau, Germany, in 1846. He immigrated to Canada around 1860, then spent time in Chicago, possibly working for a butcher. He moved to Colorado a decade later, working first as a freighter between Denver and Pueblo. Later, he raised cattle to feed miners working around Westcliffe, Colorado. He married Henrietta Palmer in 1871, and the couple eventually had eleven children—seven daughters and four sons.

Sieber was also active in local politics, and in 1876, he was elected to Colorado's first state legislature as a representative from Fremont County.

But by the mid-1880s, mining had diminished in Fremont County, and Sieber moved west again, this time to Grand Junction. He was ranching in the area by 1885 and operated with several different partners before creating the Sieber Cattle Company and the S Cross Ranch with financial backing from a banker in Pueblo. He also had a farm in Fruita, Colorado,

about ten miles west of Grand Junction, and owned a slaughterhouse there for a time.

In the twenty-first century, a paved road cuts through Colorado National Monument to take motorists to Piñon Mesa, a forty-five-minute drive from Grand Junction. But at the end of the nineteenth century, reaching Piñon Mesa required a difficult horseback ride west from Grand Junction along the Colorado River, then across the river and up one of the steep trails created by Ute Indians to the mesa high above. There was also a more easterly route, but it was also a long, difficult ride from Grand Junction.

Joe Harris was a flashily dressed cowboy who, after leaving the Sieber Cattle Company, acquired a small ranch along the Colorado River near Westwater, Utah. The ranch was roughly fifteen miles from Sieber's Piñon Mesa ranch, over rugged Indian trails that followed the Little Dolores River to the Colorado River at Westwater. Cowboys on horseback traveled such distances as a matter of course. A fifteen-mile jaunt on a steep and rocky canyon trail was of little consequence when cattle needed to be moved to better pasture or a cattleman had to visit another rancher.

Harris made the trip to accost Sieber one August day. He claimed that Sieber's cowboys pushed large herds of cattle through his ranch each spring and fall as they moved to better pastures, often tearing up Harris's fences and eating his grass. He also claimed they knowingly gathered a few of Harris's cattle in the process.

The confrontation occurred on the morning of August 22, 1902, at what the Grand Junction *Daily Sentinel* called "the summer camp of the Sieber Cattle company on Piñon Mesa, about 35 miles southwest of this city."

Harris testified at his first trial that he immediately challenged Sieber over the cattle issues and displayed his pistol, which Sieber perceived as a threat. Sieber rode to a horse belonging to one of his cowboys and pulled a 30/30 rifle from the cowboy's saddle scabbard.

Here, the accounts differ. Sieber's employees all said he approached Harris with the rifle held sideways across the pommel of his own saddle. But Harris maintained that Sieber rode with the rifle pointed directly at him. Fearing for his life, Harris said he drew his pistol and shot three times. Sieber fell from his horse. Harris stopped to pick up Sieber's rifle, then rode away.

Two of Sieber's men galloped to Grand Junction and reported the killing to Mesa County deputy sheriff George Smith that same afternoon. Later that day, Smith climbed on a train bound for Westwater, where he found Harris waiting to turn himself in.

Harris's murder trial began on October 14, 1902, and concluded on October 18 with the verdict of voluntary manslaughter. In February 1904, the court ordered the new trial that resulted in Harris's acquittal.

Harris returned to his Westwater ranch, where, according to the *Sentinel*, his life included frequent conflict with his neighbors. He had repeated confrontations with Joe Pace, who had worked for Sieber at one time. In 1909, Pace was foreman of another small ranch at Westwater, Utah. Pace owned the ranch in partnership with a woman named Florence Fuller. Harris had threatened Pace's life on several occasions and filed a lawsuit against him.

Things came to a head on October 3, 1909, when Pace discovered Harris herding some of Pace's cattle off his property. After a few words were exchanged, Pace said he believed Harris was reaching for a pistol. Pace jumped from his horse, pulled a rifle and shot Harris three times.

It turned out that Harris was unarmed, but their history turned the jurors in Pace's favor. Florence Fuller witnessed the confrontation and killing and corroborated Pace's story. The jury found Pace not guilty of murder on November 14, 1909. The *Daily Sentinel* noted the irony in the two killings:

> *Charles Sieber was shot three times by Joseph Harris on that August morning in 1902; Joseph Harris was shot three times by Joseph Pace. The killing of Sieber occurred out on the cattle range; so did the killing of Joe Harris....Sieber was killed by a cattleman with whom he had had trouble; the same can be said of the death of Harris....Harris claimed that he killed Sieber in self-defense; Pace claims that he took the life of Harris in self-defense.*

Sieber's widow sold the S Cross Ranch in 1912. But Sieber's legacy didn't end with the ranch. Many of his children, grandchildren and later descendants remained in the Grand Junction area and became business and community leaders.

SHEEP ARMY WAS ON THE MOVE DURING WAR WITH CATTLEMEN

(1908)

In January 1908, twenty-one thousand sheep—accompanied by two hundred armed men with dogs and horses—crossed the bridge over the Colorado River headed north toward downtown Grand Junction, Colorado. They then turned west toward Utah.

They were on their way from the higher mountains around Montrose, Colorado, south of Grand Junction, to the desert of eastern Utah, where they would remain for the rest of the winter and spring. Their wool would be shorn there, and they would give birth to lambs before being herded back to the high country the following summer.

Based on past experience, the owners of the sheep feared violence from cattlemen. The armed men accompanying the sheep flock were recruited from sheep herders throughout the region, and they were to protect the large herd as it journeyed more than 120 miles.

The local newspapers called this cavalcade of sheep and armed men the "sheep army," and news outlets from San Francisco to New York picked up the story and the terminology.

For decades, sheepmen and cattlemen had been in conflict throughout much of the West over the use of public rangeland owned by the U.S. government. These conflicts had been called "range wars," "sheep wars" or "sheep and cattle wars."

The problem usually involved itinerant sheepmen, often of foreign descent, who herded their sheep across public rangeland traditionally used by cattlemen who had ranches on nearby private land. A 1921 U.S.

Sheep war in Colorado, *Harper's Weekly*, October 13, 1877. *Library of Congress.*

government report called these itinerants "tramp sheepmen." It said, "As they live with their sheep and as few of them have any real estate investment, they are able to operate more cheaply than Americans, especially those with heavy land investments." They found grazing for their sheep "by trespassing on the range of bona fide stockmen and the small settlers." Such actions, the report said, "caused many bitter feuds and some bloodshed."

Even sheepmen with ranches in fixed locations often angered cattlemen as they herded their sheep from high mountain pastures to lower-elevation desert ranges. The cattlemen grew irate when the grass they viewed as their own was consumed by sheep. Many said cattle wouldn't graze where sheep had been.

Additionally, the numbers of both cattle and sheep had increased dramatically over several decades. In 1870, there were an estimated six million sheep in the West. By 1885, that number had more than quadrupled, to twenty-six million, before slowly declining.

Range wars had occurred from Texas to Oregon, in Arizona and Utah. But some of the longest-running and most violent conflicts had occurred in Wyoming and Colorado.

Masked cowboys working for cattlemen attempted to frighten sheepmen, firing guns, beating sheep herders, killing sheep. In 1894, near Parachute, Colorado—about forty miles east of Grand Junction—some 3,800 sheep had been driven over a cliff to their death.

In July 1902, six hundred angora goats had been clubbed to death by masked men on a private ranch on Piñon Mesa southwest of Grand Junction. The leader of the fourteen masked men told the goat herders they wanted the creatures off the public range because it belonged to cattle.

Occasionally, there were human deaths. In April 1907, nine months before the sheep army plodded through Grand Junction, a young sheepman from Montrose named Peter Swanson was shot and killed by masked men while camped about fifteen miles south of Grand Junction. Swanson, his brother Al and another sheepherder had been tending a flock of two thousand sheep, which they had been moving from winter quarters in Utah to the high country near Montrose.

Occasionally, the cattlemen—or cowboys who worked for them—were arrested for the crimes, but they were rarely convicted.

After the Swanson murder, sheepmen in Mesa, Montrose and Delta Counties offered a reward of $5,000 for the arrest and conviction of his killers. By the time the sheep army slowly moved across western Colorado, the reward had been increased to $10,000. As the army had traveled toward Grand Junction, it stopped near where Swanson was killed and erected a rock monument with a notice of the reward.

Even so, it was seven years before those believed responsible for his death were indicted by a grand jury and arrested. Claude Timbrel, a cowhand, was taken into custody in Twin Falls, Idaho. The other three—George Hughes, Dale Mitchell and T.D. Bowman—were all prominent Mesa County cattlemen and turned themselves in. They were scheduled to go to trial in January 1915, but all charges were dismissed when the prosecution's lead witness, Swanson's brother Al, who was then believed to be living in Oregon, failed to appear for the trial.

The sheep army that moved through Mesa County early in 1908 did so without encountering violence. It continued into Utah, where the threat subsided because cattlemen had generally left the semi-arid desert country to the sheepmen.

The range wars ended after the Taylor Grazing Act of 1934 brought regulation to grazing on the public range.

RECLUSES AND ECCENTRICS TRAVELED FAR TO MAKE PLATEAU THEIR HOME

(1899–1916)

anchers and farmers weren't the only ones who found the rugged
landscape of the Colorado Plateau attractive. A number of people
sought it because of its isolation.

Two such men were John Christian and Captain H.A. Smith. The first was
reported to be a member of the Danish royal family who fled his homeland
to avoid military service. The second was a man who honorably served his
country during the Civil War, then grew tired of his headstone-carving
business in Illinois and came west to live in a cabin he carved out of rock.

Both chose locations for their homes that were were well removed from
cities and towns or even nearby ranches. Although Christian and Smith
probably never met each other, they were contemporaries, each choosing
a homestead in a rugged canyon on the eastern edge of the Colorado
Plateau. Those homes were no more than forty miles apart as the crow
flies, but they were separated by the Uncompahgre Plateau and the deep
gorges all along its flanks. The distance between them by modern road is
nearly one hundred miles.

Christian built his cabin on a shelf above the Dolores River sometime
around 1899 using lumber he scavenged from the hanging flume described
in chapter 10. It is believed the site of his homestead had earlier been used
for a staging area while the flume was under construction.

Various sources say Christian was born in Denmark, and when he
turned twenty-one—the age for mandatory military service for his family in
Denmark—he rowed a small boat out into the North Sea, then purposely

capsized it within sight of a ship headed for the United States. The crew rescued him and brought the young man to this country.

What John Christian did prior to arriving in western Colorado and how long it took him to get here are unclear. According to one report, he worked in mines in the San Juan Mountains prior to moving to the Dolores River Valley after most of the mines closed following the silver panic of 1893.

Once in the area, Christian worked for the Club Ranch, a large cattle operation headquartered near where the uranium town of Uravan, Colorado, was eventually built, about ten miles from his homestead. He did blacksmith work for the ranch and invented a type of horseshoe designed to reduce slipping on ice and snow.

But his real interest as an inventor was to create a perpetual-motion machine. "He kept a water wheel in the Dolores River to aid him in his experiments," wrote historian Wilson Rockwell, "and he built a path from his cabin down the steep rocky slope to the river" to conduct his experiments and to gather water for his personal use.

Although Christian trusted the Club Ranch personnel, he was antisocial and "used to hide out in the rocks near his cabin when he heard people approaching," Rockwell wrote.

That tendency for solitude meant he was alone when he died in his cabin in 1916, and his body wasn't discovered until well after his death. Club Ranch employees removed his body and buried it near his cabin. Then, because of the terrible odor and fear of contagious disease, they burned the cabin.

During the time Christian was completing his journey to Dolores Canyon, hundreds of thousands of Civil War veterans were also making their way west. One of those was Captain H.A. Smith of Illinois.

A member of the 100th Illinois Volunteer Infantry during the Civil War, Smith worked his way up from private to lieutenant over the course of the war. He was reportedly wounded three times and taken prisoner once but survived to be honorably discharged in 1865.

Sometime in the first decade of the twentieth century, he closed his headstone business in Illinois and moved to eastern Colorado. He eventually ran a boardinghouse at a lumber camp in Colorado and met Indians of various tribes who showed him some of their arrowhead-making techniques, which fascinated him.

Later, he migrated farther west to Escalante Canyon, northwest of Delta, Colorado, where he built his cabin, a unique half-log, half-rock structure that Smith inscribed with the date of 1911. Well versed in rock work from

Remains of Captain H.A. Smith's rock cabin, Escalante Canyon, Colorado. *Photo by the author.*

his previous career, Smith used a red sandstone monolith for one wall of the cabin. He also chipped out a sleeping nook for himself from that same monolith, as well as cubbyholes to keep his rifles and other items. Later, he built a guest cabin behind the first one, once again using existing rock for part of the building.

Smith farmed a small plot near his cabin with irrigation ditches he dug from Escalante Creek. He is believed to have carved headstones for his neighbors and those as far away as Delta.

Smith and Christian were representative of the many individuals who found lonely locations on the Colorado Plateau to engage in their own eccentric pursuits and live largely solitary lives.

V

MINERS DIG THE COLORADO PLATEAU

MERRICK-MITCHELL MINE DISCOVERED, THEN LOST

(1879—1900s)

Even before the first Spanish explorers arrived at the eastern edges of the Colorado Plateau, tales of rich deposits of silver and gold fueled dreams for would-be prospectors and miners. But only a few deposits proved as lucrative as the rumors suggested. And in at least one case, the claimed discovery of a rich lode of silver ended in the death of two prospectors and a mystery—now nearly 140 years old—over what had been discovered.

In late 1879, two men set off from McElmo Canyon, east of present-day Bluff, Utah, to search for a silver mine in Navajo territory. One of the men, James Merrick or Merritt (various sources offer different versions of his name), claimed to have already been to the mine and found nearly pure silver.

Two months later, in February 1880, Merrick and his partner, Earnest Mitchell, were found dead. They reportedly were the victims of renegade Paiute Indians. The location of the purported silver bonanza disappeared with their deaths.

Thus, the legend of the Merrick-Mitchell Mine was born. It tantalized prospectors well into the twentieth century, even though Navajo leaders such as Hoskininni made it clear that searching for silver on their land was forbidden.

The two fortune-seekers left their mark in one sense. In Monument Valley Navajo Park—the famed scenery of many John Ford Westerns—there are landmarks named Merrick Butte, Mitchell Butte and Mitchell Mesa. They are near where the men's bodies were found, but there is no evidence that the Indian silver mine Merrick claimed to have found was nearby.

Merrick Butte, on the right, in Monument Valley, Arizona. *Library of Congress.*

Exactly who Merrick was and where he came from is part of the mystery. Some authors have suggested that both he and Mitchell were among Kit Carson's military force when they attacked Navajo strongholds and set the Indians on the forced "Long Walk" from northwestern Arizona to Fort Sumner, New Mexico, in 1864.

It's possible Merrick served with Carson, but Earnest Mitchell was a member of a settler family in the Four Corners region. His family, originally from Missouri, had lived near what became Cortez, Colorado, prior to moving to the mouth of McElmo Canyon in Utah Territory in 1878. There, they ranched and operated a trading post, and they were present when settlers with the Mormon Hole-in-the-Rock Expedition (see chapter 13) straggled into the San Juan River Valley in 1880.

Although he traded with both Navajos and Utes, Earnest's father, Henry Mitchell, also became one of the most vocal critics of federal Indian policies in the region, questioning the ability of government officials to control the Indians and threatening violence by himself and other white settlers if the Indians weren't contained on reservations.

James Merrick wandered into the Mitchell trading post in late 1879 with his story of an amazing Indian silver mine in Navajo territory. He was

seeking partners, and Earnest Mitchell was quick to join him. They later encountered members of a scouting party working for the Hole-in-the-Rock Expedition and tried to persuade members of that group to join them. But the Mormons refused.

When Merrick and Mitchell failed to return to the Mitchell trading post after more than sixty days, search parties were organized. A Navajo man led the searchers to the bodies near the buttes later named for the two men.

One of those who joined the search was Joe Duckett, later a resident of Grand Junction, Colorado, then Monticello, Utah. He spent several decades searching for the Merrick-Mitchell Mine and joined multiple expeditions looking for the lost silver lode.

His most ambitious expedition came in the winter of 1890–91. It lasted nearly six weeks and involved nine men, including Joe's two brothers, John and Thad Duckett, from Grand Junction. They traversed difficult country from near Bluff, Utah, to Navajo Mountain, north of Kayenta, Arizona. They had several confrontations with Navajos, who wanted them off their land, before they abandoned the search and returned to Colorado in late January 1891.

Another man who spent years searching for the mine was Cass Hite, a friend of Joe Duckett. Hite had prospected across the West before arriving in the Four Corners Area. His most famous attempt to find the mine was his most audacious. He reportedly rode into the camp of Navajo leader Hoskininni, sat down at the campfire and asked for food, knowing the Navajos wouldn't harm a guest. He was welcomed into the camp.

Hoskininni was an aging but important leader among the Navajos of northern Arizona and southern Utah. When Kit Carson began his effort to round up the Navajos on behalf of the U.S. government and move them to New Mexico, Hoskininni and his small band were among the few Navajos to avoid the round-up. They hid in the fractured, arid country around Navajo Mountain in northeastern Arizona.

In 1882 or 1883, Hite spent six months living with the Navajos and became friends with Hoskininni and his son. Eventually, they agreed to accompany Hite on scouting trips, but they refused to give Hite information about the lost mine's whereabouts.

One day, Hoskininni told Hite that if he ever found the silver mine, the Navajos would be forced to kill him because the site was sacred. As a consolation, he offered to show Hite places where the Spaniards had once mined gold.

Valuing his life, Hite agreed. As a result, he was shown to the Colorado River and eventually settled at what became Hite Crossing. He found some

gold and started a minor gold rush to the area. He lived and prospected in the area until his death in 1914. He may have also continued to surreptitiously search for the Merrick-Mitchell Mine.

In the mid-twentieth century, another mine—a uranium mine—was briefly operated on Mitchell Mesa with the approval of the Navajo tribe. It produced ore over several years. But it closed after mine operator Robert Shriver was killed in 1965 when the ore hauler he was driving went over a four-hundred-foot cliff.

There's no indication the uranium mine was near the lost Merrick-Mitchell silver mine. The latter is believed to be in the isolated desert and canyons somewhere between Monument Valley and Navajo Mountain, a straight-line distance of just over thirty miles. But the landscape is so rugged, so broken with arroyos, canyons and mesas, that the distance between the two is more than one hundred miles by modern highway. If it ever really existed, the location of the Merrick-Mitchell Mine remains well hidden.

18

COPPER FRENZY STRUCK UNAWEEP CANYON

(1898–1919)

After silver crashed in the early 1890s, communities throughout the West hoped for a new mineral bonanza to restore their flailing economies.

Early in 1898, people in Grand Junction, Colorado, thought they'd found their boom when copper mining gained traction in Unaweep Canyon, about thirty-five miles south of the city by rail and wagon road. This anticipated good fortune was prominently trumpeted by local publications.

"Bigger than the Klondike," blared a February 8, 1898 headline in the *Daily Sentinel* of Grand Junction. In April, the paper quoted a U.S. government official who declared that "10,000 people [will] come into this district this spring and summer" to work the copper mines.

It wasn't just local boosterism. In May 1898, the *Salt Lake City Herald* called Unaweep Canyon "A New Copper Camp with a Brilliant Future."

Even the Colorado State Bureau of Mines, which was less prone to hyperbole, stated in its annual report released in January 1898 that the Unaweep Canyon copper district "is at present attracting considerable attention and is said to have strong veins carrying high grade copper ores."

Unaweep is the anglicized version of a Ute word said to mean "where the waters divide." Unaweep Canyon runs southwest from Whitewater, Colorado, for approximately thirty-five miles. At the top of Unaweep Divide—roughly halfway through the canyon—East Creek flows east toward Whitewater, while West Creek heads west toward Gateway, Colorado, and the Dolores River.

Exploration for copper in Unaweep Canyon had begun in 1885, but there was no substantial mining activity. By early 1898, however, there were already two mining camps in the canyon.

Pearl City, which was entirely made up of tent structures, was the easternmost of the two communities. It was named for a Denver-area woman, Pearl Payne, who provided the grubstake for one of the first prospectors in the region. Copper City, which boasted a few wooden frame buildings to go with its mostly tent village, was a few miles farther west toward the top of the divide, which split the east side of Unaweep Canyon from the west.

Before the boom ended, there would be schools, boardinghouses and hotels constructed largely of tents. There were saloons, stores and families. There were a dozen small mines and many more claims.

Ore was hauled by wagon eastward down Nine Mile Hill to the railroad at Whitewater, Colorado, about ten miles south of Grand Junction. There were more stores and saloons in Whitewater of more permanent architecture.

There was even, briefly, a smelter at Copper City, although it never treated more than a few tons of copper ore.

But nearly all of the facilities and most of the people disappeared before the end of World War I, even though the economy of the United States needed large amounts of copper, first for the war effort, and later for its expanding industry.

By the time the war ended in 1918, however, other copper districts in Arizona, Montana and Michigan supplied most of the nation's needs, and smaller mining districts couldn't compete.

On top of that, the promising ore veins in Unaweep Canyon failed to live up to their hype, although the optimistic reports continued through the first decade of the twentieth century and into the second.

In 1903, the Unaweep Copper District was "forging ahead," reported the *Daily Sentinel*. More people were coming, and new claims were being developed, noted other accounts. As late as 1913, there were reports of new veins of copper being opened. One local prospector predicted "a great future" and a new copper rush in the spring.

By 1919, however, the State Bureau of Mines had soured on Unaweep copper despite its earlier optimism. "From time to time there has been some activity in this district," the bureau said in its annual report, "but no mine of any importance has yet been found."

It's no surprise that people in and around Grand Junction were hoping that Unaweep copper would bring mineral wealth to their community. Colorado had been created on such booms, beginning with the Pikes Peak

Pearl City in Unaweep Canyon, Colorado, circa 1898. *Museums of Western Colorado.*

gold rush of 1859. People nationwide knew the names of Colorado mining metropolises that had sprung up seemingly overnight and created frontier fortunes: places like Cripple Creek, Aspen, Telluride, Silverton, Ouray and—the greatest of them all—Leadville.

But busts followed booms, and the worst bust occurred when silver prices plummeted beginning in 1893. It was precipitated in large part when the federal government refused to set a base price for silver or make silver part of its monetary standard along with gold. That led to both economic and political upheaval. Just eighteen months before the Unaweep boom, in July 1896, Democratic presidential candidate William Jennings Bryan, speaking in support of a proposed federal monetary policy that aimed to restore the value of silver, declared that bankers and the government must not be allowed to "crucify mankind upon a cross of gold."

Also in 1896, gold was discovered in the Klondike, and the boom was on by 1897. An estimated 100,000 fortune seekers mushed through the snow of Alaska and western Canada over the next three years.

Nothing that sensational occurred in the Unaweep Copper District, despite the *Sentinel*'s predictions. Still, by late spring of 1898, the newspaper

111

could report that sixteen new prospectors arrived in Copper City "to join in the search for wealth," and that the stage line from Whitewater to the copper camps was operating at well beyond its capacity.

One Utah newspaper claimed there were five hundred people in each of the two Unaweep Canyon mining towns by the middle of 1898, although it's unlikely there were ever more than one hundred in each camp.

Production was measured in pounds, not tons—4,600 pounds of copper in 1899, according to one government report. How much of that was actually shipped and sold is unclear.

There had been newspapers, mail delivery and telephone lines in the copper mining camps during their heyday. There was a wood-frame store in Copper City and two schools, according to Orpha Shugar Hall, who moved to the Unaweep camps with her family as a teenager and remained until 1912, marrying and raising children.

Then the mining towns evaporated, along with the hopes of immense wealth. When Hall visited the Copper City site a half-century later, she could find little evidence of her former home.

Copper didn't become king in western Colorado. Rather, the copper story was just one of many tales in a region of mineral booms that too often seemed to go bust.

19

CASS HITE EMBRACED RUGGED LIFE IN THE WARM CONFINES OF CANYON COUNTRY

(1882–1914)

T he great mining booms of the Rocky Mountain West were primarily located at high elevations, and as a young man, Cass Hite sought his fortune in many of them—in Idaho and Montana and Colorado mountain towns such as Rico and Telluride. But by the 1880s, Hite had made an important discovery: he hated the cold and snow. So, he sought mineral wealth in the warmer canyons and river bottoms of the Colorado Plateau.

"We are not in a region where there are twelve months winter and thirteen months cold weather," he wrote in a letter published by the *Durango Herald* newspaper in the autumn of 1882, while he was prospecting near the Utah-Arizona border.

"We are only too happy to leave behind for a few months the deep snows [of the mountains], their howling storms, and their terrible frosts," Hite added. Of his new location, he said, "Instead of perpetual snow and eternal ice, 'sweet fields stand dressed in living green,' for nearly twelve months of the year."

Hite spent most of the next thirty-two years, until his death in 1914, prospecting and mining in the canyons of southeastern Utah. Most of that time was spent along the Colorado River in Glen Canyon near what was known as Hite Crossing. Cass never got rich, but he made enough money with his placer mining to support himself.

Cass Hite only left the canyon country for extended periods on two occasions. In the mid-1890s, he spent two summers in the Uintah Mountains unsuccessfully searching for a rumored lost Spanish mine. And

in 1892–93, he spent seven months in the Utah Territorial Penitentiary near Salt Lake City on a charge of second-degree murder.

His incarceration was the result of a gunfight he had in Green River, Utah, on September 9, 1891, with one Adolph Kohler, a fellow miner. Kohler had created a company with a name almost identical to Hite's company, and he tried to raise money for a mining venture in southeastern Utah by letting investors in Denver and elsewhere think Hite was involved. When Hite exposed his scam, Kohler threatened to kill him.

Hite said he went to see Kohler in Green River to settle their dispute peaceably. But when their meeting ended, Kohler lay dead and another man was wounded—the victims of Hite's well-known expertise with a pistol.

Hite always claimed he shot in self-defense after Kohler fired a rifle at him from fifteen feet and missed. Jurors in March 1892 found enough merit in Hite's story that they declined to convict him of any crime. But the determined prosecutor refiled the charges, and Hite was convicted of second-degree murder in October 1892.

He spent seven months in the Utah penitentiary before the governor pardoned him. People from around Utah and western Colorado signed

Area near Hite Crossing, Utah, in 2017. *Photo by the author.*

the petition urging his pardon, including eight of the twelve jurors who convicted him.

Cass Hite could inspire anger and fear among those he met. He was a large man and known for his skill with guns. But he also was liked and respected, even by some who sent him to prison. He was a man of many contradictions.

He may have done business with outlaws such as Tom McCarty on a few occasions, but he was partners with respected businessmen like those who developed gilsonite deposits in northeastern Utah.

Hite was friends with Jack Sumner, who had accompanied John Wesley Powell on the first expedition down the Colorado River in 1869. Yet Hite lived long enough to meet some of the first recreational boaters to travel the river.

He often expressed his disdain for the Mormon Church and for Indians in general, but he had close friends among both groups.

Hite was an educated man who gave frequent interviews to news reporters and wrote erudite letters to newspapers in Colorado and Utah. But he was also a lone miner working in one of the most isolated regions of the country.

He frequently spoke about his disdain for prospectors who rushed to a new location each time they heard of a possible bonanza. But he was also a self-promoter and a bit of a huckster, constantly predicting the next great mining boom in locations where he was mining.

Lewis Cass Hite was born in 1845 on the Hite farm in Illinois. He may have caught the prospecting bug early, when his father, Lewis Hite, headed to California during the 1849 gold rush. Cass worked on the family farm and as a printer's apprentice in a nearby town before leaving home at age twenty-one for mining camps in Idaho and Montana. After a few years, he returned to Illinois and his family.

He was briefly engaged to a local woman, but she left him, and Hite never married, although he may have had a platonic romance late in life. Shortly after the Illinois relationship ended, he departed permanently, traveling to mining areas in New Mexico, Mexico, Arizona, Texas and, eventually, Colorado and Utah.

Hite spent several years unsuccessfully looking for the lost Merrick-Mitchell Mine (see chapter 17). During that time, he met and befriended legendary Navajo leader Hoskininni. He earned the nickname Pish-la-ki, an anglicized version of the Navajo word for silver.

Cass Hite spent the next three decades prospecting at various places along the lower river. He developed what he called Dandy Crossing, which later

became known as Hite Crossing, after Hite's brother, Benjamin, who also lived there for a time. It is now at the upper end of Lake Powell.

He touted the mining prospects in Glen Canyon, saying in a letter to a Denver newspaper, "I think, candidly that the Colorado River placer fields are the most valuable in the United States." That proved far from accurate.

He worked with easterners and Grand Canyon explorer Robert Brewster Stanton to start a mechanical dredging operation in the river below Hite Crossing, but it proved an economic failure and was abandoned. He lived alone, at one point near the mouth of Ticaboo Creek, but was never a hermit. He was friendly and outgoing to those who visited. He knew a number of families in the area and was "very tender-hearted toward children," according to James H. Knipmeyer's book *Cass Hite: The Life of an Old Prospector.*

In 1907, Hite was host to a trio of boaters named Charles Russell, Edwin Monett and Albert "Bert" Loper, among the first to float through Glen Canyon for recreation and adventure. They described Hite as "a superb host, genial and [a] fine talker."

Other miners and speculators came and went. Cass Hite traveled widely across the region, making regular trips to Denver and Salt Lake City. But he always returned to the warm and sheltering canyons close to the Colorado River. He died at his cabin near the mouth of Ticaboo Creek in 1914.

FANNY WRIGHT, MINING-TOWN MADAM

(1900–1940s)

Fanny Wright was a survivor in an occupation—"the world's oldest profession," as it's been called—that was not kind to its practitioners. Physical abuse, indifferent law enforcement, disease, drug and alcohol addiction and suicide were all factors that tended to end life early for prostitutes working in mining and frontier towns of the West.

But Fanny Wright gradually improved her status among prostitutes working in the Colorado mining town of Silverton, at the eastern edge of the Colorado Plateau, and eventually ran a small bordello of her own. Later, she abandoned the business altogether, married the man who had once been her pimp and lived until her late fifties or early sixties.

Prostitutes in the West often moved from community to community or even to different states and territories as mining activity waxed and waned in various locations. Many of those in Silverton had worked in other mining towns in or around the Plateau, from Arizona and New Mexico to other locations in Colorado.

It's not known where Fanny Wright came from just before she arrived in Silverton in the early twentieth century. But she was reportedly born in Pennsylvania and apparently came west as a young woman. No photos of Fanny are known to exist, but a woman who served as her hairdresser described her as "a short plumpish woman with a very pretty face."

Fanny Wright was also known as "Jew Fanny" during much of her time in Silverton. In the 1950s, a Colorado man created hundreds of fake tokens that were supposedly from brothels around the Southwest. One

was purported to be from a Silverton brothel called "The Blair House," which was operated by Jew Fanny. But there was no Blair House bordello in Silverton, although there was a Blair Street. Fanny Wright did operate a small brothel in the town later in her career.

There was a class system among working girls of the West. Parlor houses were home to the most elite prostitutes and were frequented by the wealthiest customers. Such houses employed anywhere from five to twenty prostitutes, as well as servants, musicians and bouncers. The women working there were expected to be clean and attractive and were not to use foul language.

Next in the hierarchy were common brothels, often in back rooms or second stories of saloons. These were generally less reputable and not as clean as parlor houses.

Then came the cribs, tiny houses with one or two rooms where prostitutes worked, usually under the thumb of a pimp or madam.

The lowest ranks were streetwalkers and signboard gals, often aging, unattractive or diseased prostitutes who could no longer make the grade in the upper levels of the trade. They were forced to perform sex acts for meager funds in cheap hotels or whatever location they could find, even behind billboards.

Fanny Wright apparently operated somewhere in the mid-levels of this hierarchy. Early on in her career in Silverton, she worked in a small crib. Later, she operated her own brothel out of larger buildings and employed a number of other girls to work with her. For much of her time in Silverton, she was involved romantically and financially with a gambler and pimp named Hans Pavelich.

Wright was one of many prostitutes in Colorado who acted as a nurse during the flu epidemic of 1918–19. She survived a rough profession that claimed the lives of many younger women who worked the frontier towns during the late nineteenth and early twentieth centuries.

"Domestic violence broke out often among couples who worked as pimp and prostitute," wrote Jan MacKell in her book *Brothels, Bordellos and Bad Girls: Prostitution in Colorado, 1860–1930*. She added, "The law often turned [its] back on those who beat prostitutes, while the public felt that the 'whores' got what they deserved."

There was frequent violence among prostitutes who competed with one another, and there were occasional violent attacks, even killings, by the clients they served. Suicide was not infrequent, nor were drug overdoses, usually involving laudanum or opium. Alcoholism was a

common addiction, and pneumonia was often a killer. Venereal diseases, or sexually transmitted diseases, were a constant threat. Gonorrhea was especially prevalent.

Many communities had health rules requiring regular medical exams of prostitutes to prevent the spread of STDs, and Silverton had one of the most robust programs in Colorado. Prostitutes had to be examined by a doctor once a week and were required to display a copy of their health certificates on their walls.

Most communities in Colorado also had laws that ostensibly made prostitution illegal and prohibited other activities such as gambling and lewd behavior. But these laws were often more about raising civic revenue than banning activities. Silverton reportedly financed its sidewalks and streets in part from fines paid by prostitutes and gamblers.

Fanny Wright was said to be illiterate, but she was well liked in Silverton, so others wrote letters for her. She regularly sent money to relatives in Pennsylvania, asking them to buy a home for her when she retired. They kept the money instead.

Fanny's hairdresser said she married her former pimp, Hans Pavelich, after leaving Silverton in the early 1940s. She died in Salida, Colorado, not long afterward.

21

URANIUM FEVER FLOODS THE PLATEAU WITH PROSPECTORS

(1948–1960)

There were many mineral booms in and around the Colorado Plateau during the late nineteenth and early twentieth centuries. But few compared with the uranium boom that occurred following World War II.

"Uranium fever became a national affliction," wrote author Maxine Newell, who lived through much of the boom in southeastern Utah. "Go-for-broke prospectors poured into the little town of Moab [Utah] by the thousands....Population exploded from 1200 to 7000 in less than a year.... There weren't enough homes, schools, restaurants nor motels. Water, sewer and parking were overloaded."

It wasn't just southeastern Utah. Prospectors swarmed over lands in southwestern Colorado, northwestern New Mexico and northeastern Arizona—the heart of the Colorado Plateau. Mining camps appeared in unlikely locations, such as Calamity Camp above the Dolores River on the northern end of the Uncompahgre Plateau. And once tiny communities such as Gateway and Uravan in Colorado and Monticello and Moab, Utah, exploded with the advent of prospectors and uranium mills.

No one knows for sure how many people grabbed a Geiger counter and went looking for a radioactive fortune. An article in *True West* magazine in 1956 estimated there were at least ten thousand uranium prospectors, but there may have been more. The same article fed the uranium frenzy with a declaration that "nobody (yet) has found the mother lode." It encouraged prospectors to search for a uranium bonanza.

The article, reprinted in the Moab Museum's *Canyon Legacy* magazine in 2016, said, "Uranium is the last treasure in the earth that's left for the little guy." The man who finds the motherlode, it said, "will be worth a hundred Charlie Steens."

Charlie Steen was the standard by which all uranium fortune-seekers were measured. He was a Texas oil geologist who had left the oil business in 1949 to search for uranium. After living a desperate existence with his wife and four sons, migrating around southeastern Utah, Steen finally hit his mother lode in July 1952.

Steen and his family were then living in a tar paper shack in Cisco, Utah, forty-five miles from Moab. He owned twelve mining claims not far from Moab. But Steen was no rank amateur. His geology training led him to examine where uranium had been found before and predict where more might be found. He searched deeper and in different geologic formations than virtually everyone else. And he was ridiculed for his theories.

Steen didn't create the uranium boom, even though his success undoubtedly lured others. In fact, uranium and related minerals had been mined in the region at least since the early 1900s, beginning with radium— some of which went to Marie Curie's research in France. Later, vanadium was sought for use as an alloy in steel making.

After the first nuclear weapons were developed during World War II and the Cold War saw an increase in those weapons, the push was on to find more fuel for such weapons. Beginning in 1948, the new Atomic Energy Commission guaranteed uranium prices and offered other incentives to prospectors as it sought a viable domestic source of uranium.

Most prospectors sought uranium near the surface, primarily in the Morrison geologic formation. Steen was convinced that large deposits of uranium lay deeper, in the Chinle formation, where Geiger counters could not detect them.

By spring of 1952, Steen was nearly broke. But his wife, M.L., encouraged him to continue his quest. A friend named Bill McCormick helped him acquire another drill rig that could probe deeper than Steen's small rig. McCormick also provided money to bulldoze a road to Steen's claims.

Steen's mother, Rosalie Shumaker, sold her possessions in Houston and moved to Cisco to help care for the family and provide financial support. Steen continued to drill, pulling up core samples of rock, looking for the elusive yellow carnotite that signaled uranium. Instead, all he found was dark-gray material.

One day in early July, Steen stopped his Jeep at the only gas station in Cisco before heading to Grand Junction. The owner had a Geiger counter, and on a whim, Steen told him to aim the radiation detector at the dark-gray core samples in Steen's Jeep. The man did so, and the device chattered like it had found the center of an atomic bomb.

Surprised, Steen realized he had recovered a different type of uranium material—uraninite or pitchblende—which was found in other parts of the world but had not previously been found on the Colorado Plateau.

He named the mining claim where this uranium was found the Mi Vida, Spanish for "my life." It would change Steen's life forever.

Over the next thirty years, Steen's company and others recovered more than $500 million of uranium ore from the district where the Mi Vida was located. Steen and several different partners formed companies to explore for and mine uranium. Near Moab, they built the first uranium mill constructed entirely without government money.

The Steens went from barely surviving to being fabulously rich. Charlie rejected offers to buy his claims for $5 million. In a few years, he earned far more than that.

An avid pilot, Charlie began to fly around the West, often on little more than a whim. He and M.L. built a spectacular home on a hill overlooking Moab, which they also called Mi Vida. They held lavish parties at the house, which attracted state and local politicos. Movie stars such as Henry Fonda stopped by when they were filming on the spectacular landscape near Moab.

Charlie even dipped his toe in politics, serving a term as a Utah state senator from 1959 to 1961.

But problems developed. There were disputes with Steen's original partners, and it cost him several million dollars to buy them out. The Moab mill was eventually sold to Atlas Minerals Corporation despite Steen's objections. By 1962, the Steens had sold their interest in the Mi Vida mine and other claims, as well as the mill. They left Moab and moved to Reno, Nevada. Then, a seven-year battle with the IRS left them broke once more.

Steen's wasn't the only rags-to-riches story. There were others, such as Vernon Pick, the one-time Minnesota mechanic who was headed to California in 1951 when he learned of the uranium boom. He stopped in Grand Junction, Colorado, and picked up prospecting information from the Atomic Energy Commission, bought camping supplies and acquired a Geiger counter. Then he headed to Utah. He eventually located a mine north of Hanksville, Utah. Two years later, he sold that mine for $9 million, although it was never as productive as Steen's discoveries.

Charlie Steen and his family the day after his uranium discovery. *Museum of Moab.*

The postwar uranium boom began to decline in 1960. The AEC found it had more than enough uranium on hand. By the 1970s, there was a developing uranium market for nuclear electric plants, but it would ebb and flow over the next forty years.

Charlie Steen died in 2006 near Denver. The Steens' house in Moab is now home to a restaurant. The mill has been closed, and its tailings are being moved. Recreation has replaced uranium as the economic driver in Moab.

But for a time, the potential for uranium riches drove countless people to the Plateau regardless of the potential for failure. "There are several dozen prospectors on the Plateau today with hardly a nickel in their jeans and mining claims that may be worth millions of dollars," wrote an anonymous *True West* author wrote in 1956. "They can't get their ore out without money and they can't raise money without getting their ore out."

VI

OUTLAWS
ON THE MOVE

22

ISOLATION, POOR ACCESS MADE ROBBERS ROOST A PERFECT HIDEOUT

(1870s—1902)

When Matt Warner ventured into Robbers Roost in the early 1880s, the horse thief, cattle rustler and fledgling bank robber quickly understood why it was a good hideout: "Robbers Roost is the name of a god-forsaken section of country beginning about twenty miles east and southeast of Hanksville in the southeastern part of Utah," Warner wrote. Because of its isolation and limited access, he added, it was for twenty-five years "the greatest outlaw hide-out in the United States."

By the end of the nineteenth century, newspapers from San Francisco to New York were convinced that the Roost was the strategic headquarters for a gang of outlaws that numbered in the hundreds and was masterminded by Robert LeRoy Parker, aka Butch Cassidy. Hole-in-the-Rock in north-central Wyoming was also an important retreat.

"Each of the strongholds is both a rendezvous and a fortress absolutely impregnable," wrote the *San Francisco Call* on April 6, 1898. "They can only be reached by traversing deep and narrow gorges, [or] scaling lofty and rugged peaks."

Many newspapers repeated the fiction, invented by a Utah prison inmate, that trails to the Roost were booby-trapped with dynamite and guarded year-round by armed sentries. In the fevered journalism of the day, Robbers Roost became a cross between Ali Baba's den of thieves—complete with untold luxuries—and a military fortress.

Others took a more pragmatic view. In 1900, English adventurer Roger Pocock ventured into Robbers Roost unarmed and alone. He was treated well, he said, but he refused to divulge who told him how to find the hideout.

Like the San Francisco paper, Pocock described a widespread network of "400 professional thieves" operating from the Texas-Mexico border to Jackson Hole in Wyoming. The central stronghold, he said, was "the famous Robbers' Roost in Utah." But he dispelled the notion of any luxury retreat, describing sparse accommodations even for the few women present.

In the twenty-first century, Robbers Roost remains isolated. From Hanksville to Roost Springs—one of the critical watering holes on the Roost and a spot frequented by many outlaws—it's a straight-line distance of about fifteen miles. But to drive, it is fifty-eight miles by mostly rough dirt road. A few hundred yards from Roost Springs, along a hiking trail, stands a rock chimney—the only remnants of a cabin once frequented by Cassidy and others.

Robbers Roost is a high desert plateau isolated in all directions and with only a few access points. It covers more than half a million acres. In the center is Roost Flats, where stolen horses and cattle could feed while bandits waited to sell them. Roost Springs and several other water sources are nearby.

From the north edge of Roost Flats, one can look east to see the La Sal Mountains or north to the Bookcliffs near the town of Green River, Utah. To the west, the Henry Mountains and Thousand Lake Mountains are visible. Looking southeast, one can view the tops of the La Plata Mountains in Colorado. There is a 360-degree view with vistas of fifty to sixty miles.

Aside from Roost Flats and a few other fertile areas, Robbers Roost "is a wild country," as Warner wrote. "The wildest kind of buttes and spires and cliffs rise above the level of the mesas, worn by wind and water into every kind of human and inhuman shape you can imagine, and every color from white through pinks and reds to brown." There are sparse juniper trees on the plateaus and a few cottonwoods near springs.

Pearl Baker wrote a book about the Roost and its outlaw inhabitants based on stories she heard while growing up on a ranch there in the early 1900s. She said the first outlaw to use the Roost was Cap Brown, who, in the 1870s, stole horses from western Utah and moved them east to Robbers Roost until he was sure any posse had abandoned the chase. Then, he headed across the Colorado River, either at Hite Crossing or Moab, and sold the horses in the mining camps of southwestern Colorado.

It was Brown who introduced Butch Cassidy to the Roost in the early 1880s. Cap Brown also pioneered the use of the steep, rocky Angel Trail when coming in from the west.

During one raiding expedition, Baker said, a posse trailed Brown and two unidentified cowboys working for him to the edge of Angel Trail but backed

A stone chimney, the only remains of a cabin in Robbers Roost that was once frequented by Butch Cassidy and other outlaws. Henry Mountains in background. *Photo by Judy Silbernagel.*

off when the outlaws fired rifles at the pursuers. The posse returned fire and hit one of Brown's young cowboys in the leg. Still, he managed to lead his horse up the difficult trail only to die the next morning. Dead Man's Point, near the top of Angel Trail, was named for him.

There are few contemporary descriptions of Robbers Roost. Warner's is the most detailed, but Tom McCarty, Warner's brother-in-law and sometime crime partner, is said to have dictated his autobiography at the Roost in 1898. However, he didn't identify it by name. He did mention spending one winter in the early 1880s in a large canyon with only two entrances, one of which was known only to the outlaws. "In case we were discovered, we could not be trapped," he wrote. McCarty also said there was a considerable amount of railroad construction in the region that winter, which was typical of what was then occurring at Green River, Utah, about fifty miles north of the Roost.

Roger Pocock provided a contemporary account by someone other than an outlaw. He said that when he visited, Tom McCarty was "general manager

of the Robbers' Roost" and Butch Cassidy was his second in command. However, by 1900, Cassidy was the undisputed leader of the Wild Bunch and the Roost. McCarty, then about fifty years old, had largely abandoned criminal activity. He may have spent time there as late as 1900, but no other written account suggests he was then the leader.

Some lawmen managed to find their way into the Roost. In March 1899, Sheriff Jack Tyler of Moab led a posse in search of three horse thieves known as Silver Tip, Blue John and Ed Newcomb. They found the men in a cave at the head of Roost Canyon, southwest of Roost Springs, and a gunfight ensued. One of the outlaws was injured, but all escaped up the opposite side of the canyon. The posse retreated to Moab and did not return.

One newspaper account tells of a sheriff and deputy who supposedly reached the Roost after pursuing Cassidy and his accomplices following the 1897 Castle Gate Mine robbery near Price, Utah. But the officers were captured by the outlaws, disarmed and sent back toward Hanksville tied to their horses, a humiliating reversal of fortune.

Lawmen who ventured into the Roost were a rarity, and the outlaws usually felt secure there for extended periods. Following the Montpellier, Idaho bank robbery in August 1896, Cassidy and Elza Lay stayed the winter of 1896–97 in the Roost, except for brief trips to the outside world. They were accompanied by Elza's wife, Maude, and Etta Place, who later became consort of the Sundance Kid.

However, not everyone found the Roost so inviting. Two months was more than enough for Matt Warner. Robbers Roost, he said, "was terrible lonesome, and the silence was so deep and immense you imagined you could hear it."

23

CUNNING, GREAT HORSES SAVED BANDITS ON LONG RIDE

(1882)

In the late spring of 1882, three outlaws galloped toward Lee's Ferry on the Colorado River with a posse hot on their trail. The outlaws and their horses were exhausted. One of the three was badly wounded, and they desperately wanted to cross the river and reach their home territory in Utah.

"Our only chance to get out of Arizona was to beat the deputies to Lees Ferry in a three-hundred-mile horse race," wrote Matt Warner.

The three men—Tom McCarty, his brother-in-law Warner and a man named Josh Swett—had been stealing cattle near the Arizona-Mexico border. They had sold the cattle and retreated to a camp in the mountains of southern Arizona only to be trapped by a posse. There was a brief gunfight, during which Swett was wounded. The lawmen backed off, and the outlaws raced for Utah.

"Our plan was to avoid passing places that could give any assistance to our pursuers," McCarty wrote in his autobiography. "This was no easy matter as anyone who has traveled in Arizona will know." Water holes were few and often surrounded by people. The bandits stopped only once at a ranch, paid for watering their horses and hastily rode on. Otherwise, they stayed away from well-traveled trails and found isolated watering places.

Because the three bandits were outfitted with good horses and multiple remounts, they won that three-hundred-mile horse race. But not by much.

McCarty said the trio made it safely across the river on the ferry and planned to rest up for a day. But they spotted riders coming about five miles away and quickly mounted and rode on.

Lee's Ferry, as operated by Charles Spencer, circa 1910. *National Park Service, Glen Canyon National Recreation Area.*

Warner and Swett said it was much closer, with posse members galloping toward them as the outlaws cajoled the ferry operator to get his boat from the north side of the river to the south so they could cross.

Having escaped at Lee's Ferry, the outlaws continued northwest to Kanab, Utah, some seventy-five miles away. They briefly considered heading for Robbers Roost, but Swett needed medical attention, and that required a town.

Swett had endured the long ordeal without complaint, but at Kanab he'd had enough. He urged his partners to continue without him. He received treatment from a doctor, then settled in to await the posse. Swett recovered from his wound and was arrested by the Arizona lawmen. But local authorities made sure he was only charged with horse theft in Utah rather than allowing him to be taken to Arizona to face more serious charges. He spent a year in the Utah Territorial Penitentiary, then renounced the criminal life.

Meanwhile, McCarty and Warner continued northwest another 150 miles to the mining town of Frisco, Utah. After another scrape with the law in Milford, Utah, when they attempted to trade cattle legally but were

accused of rustling, they headed to Ely, Nevada, 150 miles west of Milford. After another grueling ride in rain and snow, McCarty was hospitalized with pneumonia, and he and Warner separated. McCarty remained in Ely and, after two months in the hospital, worked several jobs before leaving Nevada. Warner headed to his Diamond Mountain horse ranch near Browns Park, on the Colorado-Utah border.

The desperadoes had crossed some six hundred miles of the most desolate terrain on the Colorado Plateau with one wounded rider for more than half of the trip and a posse close behind. Neither McCarty nor Warner said how long the ride took. Others have estimated they rode the first three-hundred-plus miles with the wounded Swett in less than a week.

The ride "was like a prolonged war with us using all our cowboy tricks and knowledge of the country against the skill, cunning and guns of the officers," Warner wrote.

McCarty gave credit for their escape to the horses: "Anyone who has had any experience in the kind of business we were carrying on will know that in case of an emergency, a good horse may save their life."

Months before the long ride, McCarty had taken action to ensure he had the horses he needed. He traveled by train to Kentucky and then Iowa, searching for fast horses with great endurance and sound feet. He purchased three animals—Suzy, Iowa and Farmer—after testing one on a five-mile run. These three animals were rotated with other horses on the long ride. All three horses were still with McCarty and Warner when they departed Kanab, even though their other horses were worn out and had to be left behind.

Unlike Swett, neither McCarty nor Warner ended their criminal careers after the long ride. They engaged in cattle rustling and horse theft before graduating to more serious crimes. Both were involved in the 1889 bank robbery in Telluride, Colorado, with young Butch Cassidy as their partner.

In 1896, Warner killed two men while working as a security guard for a mine in Utah. Although he claimed he only fired in self-defense, he was arrested for manslaughter. Despite legal efforts by Cassidy and Elza Lay, Warner went to prison. His wife, Rose, died of cancer while he was incarcerated, and Warner went straight upon his release. He eventually served as a marshal and justice of the peace in Price, Utah. He died in 1938.

McCarty had brief spells of legal life, but he kept returning to banditry. When he attempted to rob the Farmers and Merchants Bank in Delta, Colorado, in 1893, his brother Bill McCarty and nephew Fred McCarty were shot and killed. Tom narrowly escaped, racing out of town with bullets

A well-dressed Tom
McCarty, date unknown.
Delta County (Colorado)
Historical Society.

whizzing past him. He made another desperate ride from Delta northwest over the Uncompahgre Plateau to a hideout on the Colorado-Utah border.

After that, McCarty's life is a mystery. McCarty may have been in Robbers Roost and southeastern Utah until 1900, but he had probably moved to Oregon by 1901, where he became a model citizen, working for a county road department and even the U.S. government. He is believed to have died in the Northwest around 1917.

Both Warner and McCarty had many close scrapes, but few events compared with the long ride of 1882. What's more, the ordeal had unforeseen benefits for McCarty. After his time in the Ely, Nevada hospital and a winter spent indoors, he said, "[I]t somewhat changed my appearance, so that I was almost certain no one would be apt to identify me."

ANN BASSETT, QUEEN OF THE CATTLE RUSTLERS

(1900—1913)

T he small town of Craig, Colorado, erupted in celebration in August 1913. Ann Bassett Bernard, dubbed "The Queen of the Cattle Rustlers," later known simply as "Queen Ann," had been acquitted of cattle rustling.

When the jury verdict was announced on the evening of August 16, "cowboy friends of Queen Anne [*sic*] emptied their sixshooters in the ceiling of the court room; bands which had been waiting outside blared and crowds in the streets cheered the news of the 'Queen's' acquittal," wrote one Denver newspaper. Every business and "place of amusement closed its doors, and young and old joined in the jollification."

Even a Craig newspaper that disputed the Denver account of gunfire and a circus-like atmosphere admitted there was a hearty celebration.

The case had pitted a large cattle operator—Ora Haley and his Two-Bar Ranch—against small farmers and ranchers, as represented by Queen Ann. The feud between Haley and Ann Bassett had simmered for more than a decade.

Ann Bassett was the first non-Indian child born in Browns Park, on the Colorado-Utah border just south of Wyoming. She had three brothers and a sister, Josie, who became almost as notorious as Ann herself. Her mother, Elizabeth, a southern belle turned pioneer rancher, ran the cattle operation, while her bookish father, Herb, tended gardens and served as a postmaster, justice of the peace and county commissioner.

Although Bassett's parents were both well educated, and she herself attended boarding schools in Salt Lake City and the East, Ann boasted that she grew up more cowboy than young lady.

"I had the privilege of living in the bronco West, and began life as a cowhand at the mature age of six," she wrote many years later. "I turned a deaf ear to mother's long-winded lectures upon the conduct of, and correct clothing for 'little ladies' and early adopted buckskin breeches for my personal use."

When she was sent to a finishing school in Boston, she grew tired with the lessons in proper sidesaddle etiquette. Ann was seated on an old gelding when the instructor turned away. "I threw my right leg up over the side saddle and

Ann Bassett. *The Denver Public Library, Western History Collection, Z-153.*

raked [the horse's] flanks," she said. "Then uttering a wild yell that must have scared him half to death, I put him through several range stunts while the girls screamed with glee."

The stunt nearly led to Ann's expulsion, and the next year, her father found a different school for her to attend.

Brown's Park is about thirty miles long and five to seven miles wide, ringed by low mountain ranges or river gorges on all sides. It lies just outside the northeast corner of the Colorado Plateau. However, it is closely tied to the Plateau, and much of the land where the Bassetts grazed their cattle in the summer and had cabins and corrals is within the Plateau.

From the 1880s through the early 1900s, Brown's Park was known as a frequent hideout for outlaws. It is about halfway between Robbers Roost in Utah and Hole-in-the-Rock in Wyoming.

As teenagers and young adults, Ann and Josie Bassett knew people like Robert LeRoy Parker, before he became known as Butch Cassidy, and Parker's friend Elza Lay. Josie was rumored to have been romantically involved with Parker, while Ann supposedly had an infatuation with Lay.

Some folks, however, particularly the large cattle ranchers who ran thousands of head of cattle near the park, maintained that the majority of

ranchers in Brown's Park, who rarely had more than a few hundred cattle, were themselves horse thieves and cattle rustlers.

The residents denied this, none more strongly than Ann Bassett. "Rumors were circulated to the effect that not only were we cattle thieves ourselves, but we harbored outlaws and criminals from other states," she wrote in her autobiography. "It was the old game of giving a dog a bad name and then go gunning for him, a method strictly in line with the mean practices followed by some of the big cattle organizations." The "grasping cattle barons," she added, "were the biggest cattle thieves of all time."

By the end of the nineteenth century, Wyoming cattlemen—and those who ran cattle nearby in Colorado, as Ora Haley did—sought to run small ranchers off the ranges which the large cattlemen viewed as their own. The Brown's Park ranchers formed their own cattlemen's association to keep the intruders out. So-called range detective Tom Horn was hired by the large operators to identify suspected rustlers and get rid of them.

Experienced cattleman Hi Bernard managed the Two-Bar Ranch for Haley, and he had several confrontations with Ann Bassett over Two-Bar cattle entering Brown's Park. But in 1904, Bernard married Ann Bassett. He said that Ann, clad in her finest dress rather than cowboy attire, approached him about entering into a ranching partnership. He suggested a more personal arrangement, and she agreed. He was forty-six and she was twenty-six when they married. They were in the process of divorcing when Ann was on trial for cattle rustling.

They worked well together for a number of years and built up a good cattle operation. But divorce was inevitable, Bernard later explained, because Ann always placed cattle, horses and other critters above her husband. "[A] man wants to rate above a chipmunk in his wife's affections and I could not make the grade," he said.

Whatever their differences, Hi Bernard and Ann Bassett agreed that Tom Horn, who entered Brown's Park under the name of Tom or James Hicks, had killed Ann's then fiancé, cowboy Matt Rash, in an ambush at Rash's small ranch in 1900. At the time, Rash was the head of the Brown's Park cattlemen's group and therefore an impediment to outside cattle being grazed in the park. Three months later, Horn killed Isom Dart, a black cowboy who had worked for both Rash and the Bassetts and was beloved by most people in the Park.

After the killings of Rash and Dart, Ann went on a years-long tear against Haley and his Two-Bar outfit. Haley often allowed several hundred head of his cattle to drift over the divide between his grazing land and

Ann Bassett in front of mirror, date unknown. *Museum of Northwest Colorado.*

Brown's Park. Several residents of Brown's Park spoke of seeing Ann, usually accompanied by other riders, gathering up those Two-Bar cattle and driving them into the Green River. There, many of the cattle were swept into the rapids at the Gates of Lodore and drowned. Those that survived often disappeared into the herds or larders of ranchers on the other side of the river.

Ann also may have butchered some of the Two-Bar cattle. After she left Bernard but prior to their divorce, it was rumored that she and her new ranch manager, a cowboy named Tom Yarberry, were actively rustling Two-Bar cattle and selling them to a butcher shop in Vernal, Utah.

Whether or not that was true, Ann maintained she and Yarberry had *not* killed a Two-Bar steer at her ranch on Douglas Mountain, just outside Brown's Park, in 1911. Bill Patton, then manager of the Two-Bar, claimed the two had stolen and killed the steer. He had Ann and Yarberry arrested.

The case came to trial in August 1911 and ended in a hung jury. A new trial was held in August 1913. By that time, Yarberry had disappeared, and Ann stood trial alone. Additionally, one of the main defense witnesses from the first trial had been shot and killed the year before. Still, there were significant questions about ownership of the butchered steer. Then, Ora Haley took the stand and demonstrated his own duplicity. He had long told county tax officials in northwestern Colorado he owned only 5,500 head of cattle. On the stand he inadvertently proclaimed he owned 10,000. Jurors, who already disliked and distrusted the big cattlemen, had more reason to rule in Ann's favor.

When the trial ended with her acquittal, so did the worst of the Moffat County range war. Ann Bassett later married Frank Willis and moved around the West with him, finally settling in Leeds, Utah. But they returned each summer to Brown's Park. Ann died in 1956, and her ashes were buried in her beloved Brown's Park.

VII

MECHANIZATION
AND MOBILITY

25

UINTAH RAILWAY CONQUERED BAXTER PASS

(1904—1939)

There's not much left of Shay No. 3. A few scattered pieces of iron—and one large chunk of steel that may have come from the locomotive's boiler—lie in heavy oak brush below the old railroad grade near the top of Baxter Pass on the Colorado-Utah border.

Shay Engine No. 3 was a locomotive on the Uintah Railway, which operated between Mack, Colorado—about twenty-five miles west of Grand Junction—and Dragon, Utah, from 1904 until 1939.

No. 3 went off the tracks during a snowstorm on February 10, 1909. When it topped Baxter Pass during that terrible storm, it "shot down the mountain side at a fearful rate of speed," the *Vernal Express* reported on February 12. "It rolled over and over many times, and when it stopped there was nothing left but scrap iron."

Engineer Joseph E. "Doc" Lane was killed in the wreck, along with an unnamed Greek worker. Although much of the locomotive and other cars were recovered by railroad crews in the following months, some of the wreckage was left behind, providing a reminder of an age when railroads ruled ground transportation but crashes were common.

The first trains powered by steam locomotives began operating in England early in the nineteenth century. By the middle of the century, they were ubiquitous throughout much of England, Europe and the eastern part of the United States. But railroad tracks didn't cross the entire North American continent until 1869, when the famed golden spike was driven northwest of Salt Lake City to connect tracks of the Union Pacific and Central Pacific Railroads.

Crossing the desolate landscape of the Colorado Plateau was another matter. It wasn't until the early 1880s that the Denver and Rio Grande Railroad (D&RG) pushed westward from Grand Junction to Green River, Utah, then northwest to Salt Lake City. And it was another two decades after that before tracks were completed between Salt Lake City and Los Angeles, California, making a full east–west crossing of the Plateau, albeit with a jog to the north.

Numerous spur lines were constructed to reach specific towns or mining areas, such as the Ballard & Thompson Railroad, a five-mile spur built by the D&RG to reach the coal mines of Sego, Utah, north of Thompson Springs.

The Uintah Railway, which began operating in 1904, was created out of desperation. Samuel Henry Gilson and Bert Seaboldt had discovered commercially valuable deposits of gilsonite in northeastern Utah. They knew the substance was useful for varnishes, inks and paints. Later, it would be utilized in the automotive industry, for oil drilling and in making asphalt.

But the isolated deposits at Dragon, Utah, could only be reached by horse-drawn wagon, which was slow and expensive. The partners approached the D&RG about extending a spur from Grand Junction over Baxter Pass to Dragon, a distance of fifty-three miles. D&RG officials rejected the idea.

The gilsonite company was sold to a group in St. Louis headed by Charles O. Baxter, for whom the mountain pass was later named. Baxter's group, which became the General Asphalt Company, decided to build its own railroad. To do so, it had to construct a new community in western Colorado, where the Uintah's narrow-gauge railroad could connect with the standard-gauge D&RG. Mack, Colorado, was born and named for another company official.

The Uintah Railway's route was troublesome. The tracks gained 2,012 feet in elevation as they climbed Baxter Pass. There were thirty-seven wooden trestles in the twenty-eight miles between Mack and Atchee, Colorado, at the base of Baxter Pass. And that was the easy section. In twelve miles from Atchee to the Utah side of the pass, there were 233 curves, many so tight that conventional locomotives couldn't maneuver around them.

That's where the Shay engines came in. Produced in Lima, Ohio, the Shays had side-mounted pistons and gear-driven axles, and they produced large amounts of power for their size. Also, both the front wheels and rear drivers swiveled, allowing the locomotives to better negotiate the sharp curves.

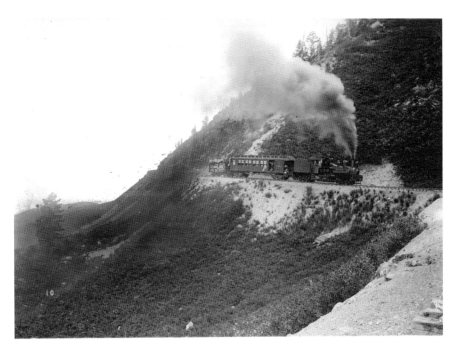

A locomotive with passenger and freight cars coming down the east side of Baxter Pass. *Museums of Western Colorado.*

The Uintah Railway ran conventional Baldwin narrow-gauge locomotives on the first half of the westbound trip from Mack to Atchee. There, the engines were switched to Shays to power over the pass. Remnants of the switching yard, including a locomotive shop, remain today in the ghost town of Atchee.

Although the Uintah Railway was primarily created to haul gilsonite, it also carried mail, passengers and other freight, and it was a busy line. But the Uintah crews fought the weather constantly. Flash floods often damaged trestles on the lower part of the route, and heavy snowfall required special plowing runs at higher elevations. That's what Shay No. 3 and its crew were doing when they wrecked—one of several bad crashes in the area that month.

On February 7, a fireman and brakeman on the D&RG main line were killed when their freight train hit a storm-caused rockslide west of Grand Junction. And two days after the wreck of Shay No. 3, the blizzard created a snowdrift two miles long on Baxter Pass that halted rail traffic for a week. During that week, no mail reached Vernal, Utah.

At the time, Vernal mail was routed through Mack via the Uintah Railway, then by wagon from Dragon to Vernal. A decade later, truck service

between Craig, Colorado, and Vernal provided a shorter mail connection devoid of high mountain passes.

Ultimately, trucks, better roads and a pipeline made the Uintah Railway superfluous. In May 1939, the last train made the trip from Mack to Dragon.

However, during its thirty-five years of operation, the Uintah Railway was critical to the small communities it served. Its train crews regularly braved the rough weather and difficult trips to ensure the railway kept operating. Wrecks were not uncommon, especially when trestles in the lower section failed. But none was as spectacular as the wreck of Shay No. 3.

CARNEGIE HORSES HAULED FOSSILS AT DINOSAUR NATIONAL MONUMENT

(1910 – 1925)

Earl Douglass needed horses and wagons—lots of them—in the autumn of 1910. He had to haul dinosaur bones he had discovered near Jensen, Utah, to the closest railroad depot, which happened to be at Dragon, Utah, sixty miles to the south.

Once on a train, the fossils would go to the Carnegie Museum in Pittsburgh, Pennsylvania. Andrew Carnegie was sponsoring the research Douglass conducted at what would later become Dinosaur National Monument. The horses and mules Douglass hired are now called the Carnegie Horses, and they were a critical part of the transportation of the fossils for nearly two decades.

Once the plaster-encased fossils reached Dragon, they were put on the Uintah Railway and chugged another sixty miles over Baxter Pass, then into Mack, Colorado, where they would be transferred to Denver and Rio Grande Railroad (D&RG) cars that were headed east to Pittsburgh.

Before the bones could make the journey on rails, however, they had to be hauled to Dragon by teams of horses or mules pulling wagons laden with plaster of Paris–covered fossils in wooden crates. It was no simple task.

"Had an awful time getting the heavy specimen of the carnivorous dinosaur into the wagon box," Douglass wrote in his journal on October 31, 1910. "The bottom broke out and the boys wired it up." Another specimen did fine until it was in the wagon: "Then it nearly tipped over. Nearly all the horses balked and the result was the [fossils] did not all get loaded."

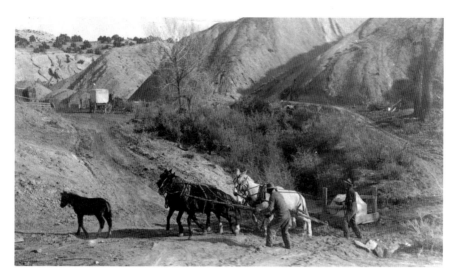

Carnegie Horses pulling fossils out of Dinosaur National Monument, circa 1916. *National Park Service, Dinosaur National Monument.*

Douglass traveled to Mack to supervise the first transfer of the fossils to the D&RG cars on November 8, 1910. He was disgusted by the way the railroad workers handled his precious cargo. "We saw our mistake after we got to loading," he wrote in his journal. "We ought to have taken one of [our] crews and done the things to suit ourselves." The D&RG crews in Mack "were very poor hands at handling that kind of freight and it got pretty badly shaken up," he said.

Still, all the fossils made it safely to Pittsburgh. They would continue to do so for the next fifteen years. To get the first fossils from Jensen to Dragon, Douglass initially hired nine teams of horses and wagons, the first of many teams involved. Over the next fifteen years, Douglass and his workers excavated and shipped about 350 tons of dinosaur bones and related material, said Sonya Popelka, interpretive operations supervisor at Dinosaur National Monument.

Most of the bones went to the Carnegie Museum, but some were later sent to institutions in Salt Lake City; Denver; Washington, D.C.; and fifteen other locations around the country. A few were sent overseas.

Nobody knows how many horses and mules were involved in hauling the fossils over fifteen years. But it's clear they were indispensable to Douglass' efforts.

Earl Douglass was raised in Medford, Minnesota, where he became a teacher and formed an interest in paleontology, primarily ancient

mammals. He taught in small communities in Minnesota, the Dakotas and Montana while he obtained a master's degree in paleontology. In 1902, he began work for the Carnegie Museum, which initially supported his search for ancient mammal fossils. But this was the age of large dinosaur discoveries. Every major museum in the country wanted dinosaur skeletons—the bigger the better.

By summer of 1909, Douglass had clear orders from the Carnegie to "dig up dinosaur bones east of Vernal." The area was known to have formations of Jurassic-era rock similar to those in which major dinosaur discoveries had been made elsewhere in the West. But paleontologists had largely ignored the region around Vernal.

East of Vernal, near the Green River and the small farming town of Jensen, Douglass made his first major discovery on August 17, 1909: "At last in the top of the ledge…I saw eight of the tail bones of a Brontosaurus [now called Apatosaurus] in exact position," he wrote. "It was a beautiful sight."

The bones were part of a jumble of fossils of four hundred to five hundred individual dinosaurs of many different species that were washed into an ancient riverbed. Over eons, that riverbed solidified into rock and was raised into a near-vertical cliff face.

Although Douglass and his crews removed many of those fossils in the cliff face and large portions of the cliff itself, a significant amount remains. The bones of perhaps one hundred individual dinosaurs are present in the jumbled rock wall. Today, people can see and touch the fossils at the Dinosaur Quarry Visitors Center at Dinosaur National Monument near Jensen.

Douglass was one of the first paleontologists to understand that people want to see dinosaur bones as they were discovered, not just in museums. So, he pushed hard, even after Dinosaur was designated as a national monument in 1915, to provide a site where visitors could see bones in place. He didn't live to see the modern visitors' center, but it was part of his vision.

He also grew attached to some of the horses and mules used to haul the fossils, especially a team of white mules named Bill and Joe. They were originally part of the skidding and hauling crew, but Douglass bought them to pull a buggy for his wife, Pearl.

Earl Douglass died in 1931. He spent his final days on a small plot of land he owned with Pearl just outside of Dinosaur National Monument. It is now within the monument's borders.

In 2009, the Carnegie Museum returned a single wooden box to Dinosaur National Monument. It contained the humerus of a large, plant-eating dinosaur that had been excavated and crated by Douglass nearly a century

earlier. It was never removed from its crate or plaster cast. That wooden box, with its precious fossil, is now on display at the monument's visitor center. It traveled back to Jensen by truck. But the Carnegie Horses and the Uintah Railway deserve credit for hauling it out originally.

AUTO ENTHUSIASTS STRUGGLED ON MIDLAND TRAIL

(1912–1914)

In October 1912, A.L. Westgard visited Grand Junction, Colorado, in an automobile. At the time, Westgard was a field representative for the American Automobile Association, and he was exploring a possible route for a national coast-to-coast auto highway. This particular route was to run through Grand Junction and on to Salt Lake City, Utah.

But to reach Salt Lake City, Westgard had to cross the high desert of western Colorado and eastern Utah. It would take him and a convoy of enthusiastic Grand Junction motorists twelve days to reach the Utah capital, with most of that time spent struggling across the rain-soaked clay, the arroyos and ravines of the Colorado Plateau between Grand Junction and Price, Utah. Amazingly, it required thirty-three hours alone for the convoy to go from Mack, Colorado, to Cisco, Utah, a distance of just thirty-five miles.

"After surmounting almost inconceivable difficulties, at times carrying cars bodily across deep ravines or across flooded rivers and battling with sticky adobe mud caused by two day's rain, besides having serious breakdowns of almost every one of the eleven cars, we finally reached the town of Price," Westgard wrote in his 1920 book, *Tales of a Pathfinder.*

Westgard dubbed this route "the Midland Trail," and the Midland Trail Association was formed in Grand Junction later that year to promote it. But there was fierce competition for the first national coast-to-coast automobile route, which was expected to bring untold numbers of tourists to communities along the roadway. Some people wanted "The Overland Trail," which closely followed the route now used by Interstate 80 across southern

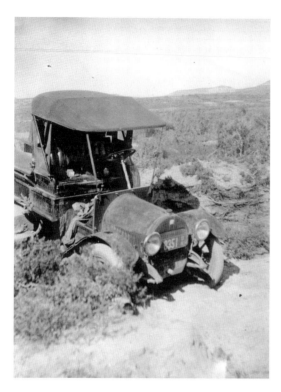

A mail truck crossing deep wash in eastern Utah, circa 1916. *Museum of Moab.*

Wyoming, then to Salt Lake City and on to San Francisco. Additionally, a proposed "Northwest Route" aimed from Chicago northwest to Seattle, while a "Southern Route" to Los Angeles was to cut through New Mexico and southern Arizona. Much of it later became famous as Route 66.

In 1912, Westgard was on assignment from AAA to scope out all of the routes and determine their difficulties. Shortly before he arrived in Grand Junction, Westgard laid claim to one of his several "firsts" in automobile travel. "Our car was the first to cross Berthoud Pass, over the Rocky Mountains west of Denver," he wrote. "The elevation is 11,306 feet and the summit of the pass comes very near being the top of the world."

He already knew the terrain west of Grand Junction would be troublesome. He had heard that other motorists had attempted to drive the section from Grand Junction to Salt Lake City and had failed. "The rough country and absence of culverts or bridges across washes and ravines" forced the motorists to ship their automobiles on railroad cars "for a considerable distance in every case," he noted.

Consequently, Westgard arranged for a meeting of the chamber of commerce in Grand Junction in October 1912. At this meeting, he said, "I

explained the importance to the city of being located on a transcontinental trunk highway and especially on one with so many scenic attractions as the Midland Trail."

It's unlikely that Grand Junction's civic leaders, always eager to find ways to boost their community, needed Westgard to explain to them the advantages of a transcontinental highway. In fact, they may have pushed him to pursue the route through their valley.

In any event, at the chamber of commerce meeting, Westgard asked for volunteers to accompany him to Salt Lake City, "suggesting that three or four husky fellows occupy each car to enable us to surmount all obstacles by sheer physical strength." He quickly had enough volunteers to occupy ten cars, plus his own automobile. The expedition was soon underway despite the rainy autumn weather and the muddy conditions of the desert to the west of Grand Junction.

More than a year later, federal officials announced that the Overland Trail had received the nod as the first coast-to-coast highway, and it eventually would become known as the Lincoln Highway. But the Midland Trail was not abandoned. It, too, was built and would become known as the Roosevelt Highway. A southern route through Colorado, essentially following what is now U.S. Highway 50, united with the Midland Trail or Roosevelt Highway in Grand Junction. It was called "the Rainbow Route."

By 1914, cross-country car travel was booming. The *Daily Sentinel* reported in March that the American Automobile Association expected as many as 300,000 autos to travel to California that year by either the Overland Trail or Midland Trail. Encouraged by the potential economic boost to come from the highway, people in and around Grand Junction pledged in April 1914 to raise money to improve the road not only in Colorado but also in Utah all the way to Thompson Springs, about seventy-five miles west of Grand Junction.

Westgard visited Grand Junction again in 1913 and drove the highway to Salt Lake City once more. He marveled that the trip between the two cities required only two days that year rather than the twelve it had taken previously. It was evidence, he said, "of the work which had been done during the year to eliminate the worst places on this entire route."

Even so, he fondly remembered that first trip and the Grand Junction automobile enthusiasts who had accompanied him. "It was with genuine regret that I parted with those fine fellows, 'the boys of 1912,'" he wrote.

DRIGGS AND ADAIR TOOK TO THE SKIES ABOVE THE PLATEAU

(1914—1923)

As darkness gathered one October evening in 1920, Arnold Adair swept up western Colorado's Unaweep Canyon in his biplane, then climbed above the canyon walls and soared over the treetops of the nearby forest reserve. When he spotted a small forest fire burning in the trees, he banked low over the blaze and dropped chemical bombs to try to extinguish the flames.

Adair didn't put the fire out, but he demonstrated to his forest ranger passenger that "aero planes" could be used to quickly spot and limit the spread of wildfires.

Arnold Adair and his high-flying firefighting were fiction. They burst from the imagination of a man who knew both Unaweep Canyon and early aviation: Laurence La Tourette Driggs. He wrote several novels and magazine articles featuring Adair.

Driggs and Adair were ahead of their time. The first actual experiments using aircraft to fight wildfires didn't come until the 1930s, and it wasn't until 1947 that the first chemical retardants were dropped on fires from the air.

Driggs's name is recognized in western Colorado as that of the man who built Driggs Mansion, a crumbling rock structure that was really no more than a large cottage, in Unaweep Canyon, some twenty-five miles south of Grand Junction.

When Driggs and his family began work on their home, probably in 1914, it was in an isolated part of the West, but there were already well-established ranches in the area. The railroad stop at Whitewater, Colorado, about twenty miles to the northeast, was a bustling community.

Cover of one of Laurence La Tourette Driggs's books featuring Arnold Adair. *Museums of Western Colorado.*

Born in 1876 in Saginaw, Michigan, Driggs grew up in Oregon, then became a lawyer in New York. He married Mary Ogden in 1904, and the couple had two sons. Driggs became a deputy attorney general for the state of New York in 1909. His life changed in 1913, when he learned to fly. He soon became an outspoken advocate for aviation and one of America's leading authors on the subject. Before World War I ended, Driggs had conjured up the character of Arnold Adair, "American Ace." Adair appeared in four novels from 1918 to 1930. He was also the lead character in several short stories, such as "Fighting Forest Fires from the Air," published in *Outlook* magazine in January 1921.

It's not clear whether Driggs ever flew over the Colorado Plateau, but his Arnold Adair firefighting article is based on Driggs's clear knowledge of the region and suggests he may have seen it from the sky. In the article, Adair flies to a ranch in Unaweep Canyon to visit a buddy from his World War I flight squadron:

> *During the last week the two aviators had again flown together unceasingly, over the thirty miles northward to the nearest railway town* [Whitewater]; *to the southward, deep within the rugged mountainous country of the Dolores…away over the picturesque mesa land to the east and the sullen Utah plains to the west.*

Airplanes were still rare in the region in 1920. The earliest known flight in Utah occurred on January 30, 1910, in Salt Lake City. The first airplane in western Colorado arrived by rail in Grand Junction on August 27, 1912. Salt Lake City didn't have a commercial airport until late 1920, and Grand Junction's municipal airport opened ten years later. Smaller communities on the Plateau joined the aviation era even later.

It's not clear what piqued the Driggs family's interest in western Colorado, but by 1915, Laurence and Mary had moved their family to Unaweep Canyon. In 1916, Driggs acquired the mining rights for the Mayflower

copper mine in Unaweep Canyon, and he eventually acquired 320 acres associated with the mine. In 1914 or 1915, Driggs hired the Grasso family, Italian stonemasons from Grand Junction, to build a home—the sandstone structure now known as Driggs Mansion.

But Driggs was gone during much of the construction. He and Mary were in Europe. In fact, Laurence was taking flying lessons in Germany when World War I began, but he quickly moved to join the Allies. He observed and wrote about air battles in World War I, becoming one of the premier authors on aerial combat. He met air aces like U.S. pilot Eddie Rickenbacker, with whom he co-wrote a book on heroes of the air war. He also accompanied Britain's Royal Air Force to the front. Later, he joined the Royal Air Force Flying Club, a model for the American Flying Club that Driggs organized in 1918.

Driggs enthusiastically promoted and explained aviation to the American public, discussing issues such as military airplanes and using aircraft to assist commercial fishing. He also lamented in print the fact that the United States wasn't rapidly developing a commercial air industry as some European nations were. He touted the safety of flying, gave regular talks about aviation and garnered publicity with events such as taking the founder of the Girl Scouts, then seventy-year-old Juliette Low, for a ride in his biplane.

Throughout the 1920s, he and Mary were active members of the East Coast elite, getting frequent mention in both society columns and news articles. Perhaps that's why they lost interest in western Colorado. They sold their rock home and Unaweep Canyon property in 1923.

Driggs died in 1945 in Maryland. He left behind an iconic structure in Unaweep Canyon. But his larger legacy is the U.S. aviation industry. He was an early investor in the industry through Colonial Western Airways, a predecessor to American Airlines. More importantly, he was a tireless advocate and booster for aviation—with the daring assistance of Arnold Adair.

VIII

FAR-FLUNG
ENTERTAINMENT

PEOPLE TRAVELED MANY MILES TO DANCE THE NIGHT AWAY

(Late 1800s—1950s)

When Anita Clark was a young woman in the 1940s, weekends meant music and travel. She joined her family's dance band, the Purdy Mesa Cowhands, and they performed in rural school houses, community halls and elsewhere in western Colorado.

When the Cowhands played the Summit School in Unaweep Canyon, "They never let us quit until the sun came up," said Clark, who was Anita Black before she married. Dances were usually scheduled to end by 2:00 a.m., but "they would pass the hat to keep us going" all night.

Clark grew up on a ranch near Whitewater, Colorado. She played piano and accordion in her family combo. But she and the other band members had to fit their musical performances in with work on the ranch. All of them, including Anita and her sister Wanda, were experienced cowhands.

That was true for George Decker as well. He was not a performer but an eager attendee at a dance hall known as COPECO, near Grand Junction, Colorado, in the early 1950s. It was established in the barn of an old pear farm called the Colorado Pear Company, from which the dance hall took its acronym name.

But Decker didn't live anywhere near Grand Junction then. He grew up on his uncle's ranch along the Colorado River, roughly 170 miles northeast of Grand Junction. When he was a teenager, the older ranch hands would take him along on trips to COPECO because they needed a sober driver for the return trip. Spending the night in Grand Junction was not an option.

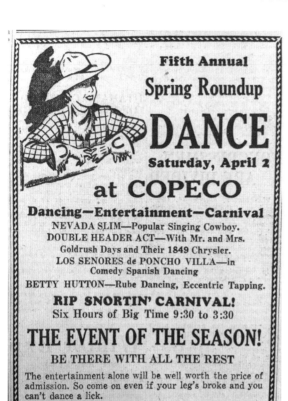

Left: Newspaper advertisement for a 1938 spring dance at the COPECO nightclub near Grand Junction, Colorado. *Priscilla Magnall, Mesa County, Colorado, Historical Society.*

Below: A group of musicians on the road between La Sal, Utah, and Moab, Utah, circa 1920. *Museum of Moab.*

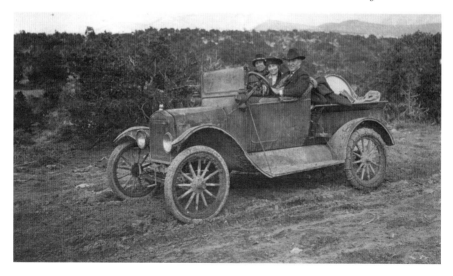

"We'd leave on Saturday afternoon and come dance until it shut down" sometime near dawn, recalled Decker. "We'd be back at the ranch in time for Sunday chores."

Clark's combo traveled in roughly a one-hundred-mile radius from Whitewater to perform. Sometimes roads were so bad, the band members and their instruments had to be ferried to the dance halls in army troop carriers. Other times, they played in rough wooden cabins in the mountains called cow camps. The entertainment-starved cowboys there were eager for the show and helped haul the instruments to the cabins, she said.

Clark, Decker and many others like them were carrying on a tradition that began long before the mid-twentieth century. For the people living on the isolated, rugged landscape of the Colorado Plateau, various forms of recreation developed. These included horse racing and gambling and sports like baseball. But dancing has been around as long as any of these activities.

The mythical Native American flute player, often called Kokopelli, has been found on rock art panels throughout the Southwest, some dating back one thousand years. Often, he appears to be dancing as he plays his flute, and some legends say he inspired the early natives to dance.

Ute Indians of the Colorado Plateau have long held spring Bear Dances to bring families and groups together to celebrate the start of a new year, to show respect for the Bear and the natural world and to socialize before departing into small family groups for the summer. A century ago, it wasn't unusual for Utes from southwestern Colorado to travel by horseback to the Uintah Reservation in northeastern Utah, a distance of nearly four hundred miles, to engage in days of dancing.

There are other Ute dances. But the Bear Dance is the most social gathering, and it allows for interaction between women and men. It is still performed annually throughout Ute lands.

Early white settlers on the Colorado Plateau were also fond of dancing and its social aspects. Members of the Church of Jesus Christ of Latter-day Saints—the Mormons—were noted for their dances, whether they were moving to new locations or living in established communities. Mormon families of the Hole-in-the-Rock expedition danced frequently under the stars through the cold winter of 1879–80.

Star Hall was constructed by Mormons in Moab, Utah, in 1905. It was used for educational purposes, for communal dinners and for dances that, according to early accounts, lasted for most of the night.

Such church-supported dances naturally had a different tenor than many of the dances in ranching country, where cowboys and farmers often looked for any event to cut loose.

At the Bare Valley School on Blue Mountain, in northeastern Utah, a dance was held in 1924 in conjunction with a school election. "I didn't dance much, though," recalled one resident of the area. "I took one drink of Charlie Mantle's whiskey. It was about 200 proof....I passed out and laid out under a serviceberry bush all night."

Drinking was a big part of the COPECO dances, and the dance hall developed an unsavory reputation due to frequent fights and rowdiness.

Anita Clark said alcohol was usually present at the dances where she and the Purdy Mesa Cowhands played. "Everybody had a bottle in the car," she recalled. But booze rarely made it into the dance hall itself, and there were few conflicts involving inebriated participants.

The rural dances attracted participants of all ages. "Everyone went to the dances from grandparents down to tiny babies and toddlers," recalled one woman of the dances in Gateway. When the youngest children got sleepy, beds were fashioned from chairs turned against the walls and covered with coats and blankets. But the revelry continued. "People of all ages danced....The parents and grandparents would be dancing with the very young."

NORMAN NEVILLS INVENTED COMMERCIAL RIVER RUNNING

(1938)

Norman Nevills just wanted to take his bride, Doris, on a honeymoon adventure in December 1933 when he built his own boat to float the San Juan River. He wasn't contemplating an entirely new industry.

But five years later, when he was attempting the first commercial boat trip down the Green and Colorado Rivers and through the Grand Canyon, Nevills's efforts were big news. Newspapers from Utah to New York carried updates on the trip's progress. When the group didn't show up at Lee's Ferry by July 4, there was considerable anxiety.

One reason for concern was the fact that water level in the Colorado River was at a ten-year high. An experienced "river rat," when asked about the expedition, said, "The water's too high. You couldn't pay me to join them."

So, there was relief a few days later when Nevills and his three-boat armada neared Lee's Ferry. "River party sighted. All believed safe," a headline in the Grand Junction *Daily Sentinel* proclaimed on July 8.

A handful of other boaters had successfully run the Green and Colorado Rivers since John Wesley Powell's team did it in 1869. But it remained a dangerous undertaking. In the decade before Nevills's run, several people had been killed, including Bessie Hyde and her husband, Glen, on their honeymoon in 1928.

Nevills had two women on his 1938 expedition. And the Grand Canyon was "a mighty poor place for women," said ninety-year-old James Fennemore, a veteran of Powell's second expedition in 1871–72.

Buzz Holmstrom, who successfully floated from Green River, Wyoming, to Lake Mead *alone* in 1937, refused to join Nevills's 1938 trip because, he said, women were "too much of a handicap."

That didn't faze Norm Nevills, who floated rivers with his wife, his mother and other women prior to the 1938 trip.

A California boy, Nevills had moved to tiny Mexican Hat, Utah, in 1928, when he was twenty. There, he and his mother joined Norman's father, Bill, an oil wildcatter with a well near Mexican Hat. Norm worked with his father and assisted groups working on the San Juan River. He learned river running on small fold-up rowboats, which, he decided, were not adequate for his honeymoon trip. So he designed and built his own boat, the first of many.

The honeymoon trip made it only twenty-one miles downstream in the low water of the San Juan. Doris, Norm and a friend named Jack Frost hiked out of the river canyon, then back to Mexican Hat.

Over the winter, Nevills constructed a second boat. Doris and Norm launched in March 1934, with Norm's parents aboard for the first part of the journey. Then Frost and his wife joined the trip to Copper Canyon, seventy miles downstream from Mexican Hat.

With a growing reputation for river running, Nevills made a 1936 trip carrying three California men down the San Juan and Colorado Rivers to Lee's Ferry. He also began contemplating a trip through the Grand Canyon.

As he planned, Nevills could learn from those who preceded him. Julius Stone and Nathan Galloway ran the canyon in 1909 in a boat Galloway designed. Brothers Emery and Ellsworth Kolb ran it in 1911 and provided the first motion pictures of a river expedition. Nevills consulted with Emery Kolb during his 1938 trip. Government survey parties floated the Green and Colorado in the early 1920s and created maps that Nevills used on his trip. Holmstrom's solo trip generated interest in Nevills's expedition.

That expedition had its beginning in 1937, when University of Michigan botanist Elzada Clover visited the Nevills lodge in Mexican Hat. Nevills and Clover planned a trip for the following summer. There would be three paying passengers: Clover, lab assistant Lois Jotter and Gene Atkinson, a grad student in zoology.

Nevills designed new vessels for the trip, which he called cataract boats. He and his friend Don Harris built three boats: the *Botanist*, the *Mexican Hat* and the *Wen*, an acronym of Norm's father's initials.

Unlike later river dories with their upswept prows and sterns, the Nevills boats were relatively flat. Designed to carry one oarsmen and one or two passengers, plus gear, the boats had wooden frames and hulls made of a

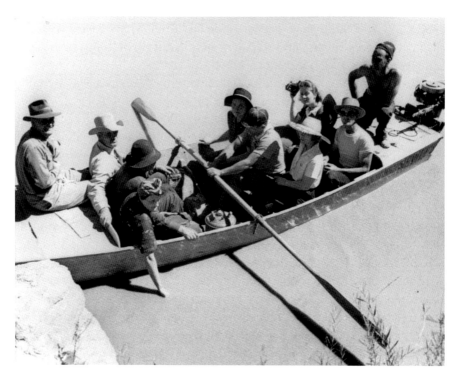

Norman Nevills, kneeling at the back of his boat filled with passengers for a 1936 trip on the San Juan River. *Museum of Moab.*

new marine-grade plywood. They proved to be surprisingly resilient. After one particularly challenging rapid in Cataract Canyon on the Green River, Nevills wrote in his journal: "Twenty-one miles an hour…The sensation is indescribable! And how the boat rode!"

Nevills would pilot one of the boats, and he hired Harris to handle a second boat. The third boatman was Wilbur "Bill" Gibson, a San Francisco photographer whom Nevills hired to take photos as well as handle a boat. He later regretted that decision. "Bill [Gibson] is just useless as he doesn't know how to work," he wrote on June 26, when he realized the expedition wouldn't reach Lee's Ferry by July 4. "Gene [Atkinson] is worse than nobody at all. Harris is good at lining and is my mainstay."

Lining was the practice of dropping boats through rapids by rope, with passengers walking.

During the first half of the journey, above Lee's Ferry, there were several mishaps. The *Mexican Hat* was poorly tied at one point and swept into the current with no one aboard and down through a rapid as Nevills and his

crew frantically chased it. Gibson flipped another boat in a large rapid, and it crashed through upside-down with Atkinson clinging to it while Gibson tumbled through the rapid on his own. All survived, but the event took its toll.

"The worry of this trip is hard, and the responsibility is tremendous," Nevills wrote in his journal that night. "I sometimes wish I had never taken this trip as expedition leader."

In fact, Nevills's journal reveals a man who bounced frequently from incredible self-confidence to depression and near-defeat. But he did not give up.

On July 8, the expedition arrived safely at Lee's Ferry. Publicity-conscious Nevills had all members of the party reenact their safe landing for a movie news cameraman who had been unable to capture the first landing on film. Then, Nevills caught a ride back to Mexican Hat for a quick visit with his family and to recruit new boatmen.

Harris had to return to work. But the much-maligned Gibson agreed to continue. To Norm's relief, Atkinson left the expedition at Lee's Ferry, while the two women continued on.

The expedition shoved off from Lee's Ferry on July 11 with boatmen Lorrin Bell and Del Reed joining the crew, as well as Emery Kolb as a passenger. Despite its dramatic rapids, the Grand Canyon proved less eventful for the expedition than Cataract Canyon. Norm clearly enjoyed it.

"The little rapids are lots of fun," he wrote on July 16. "The medium sized ones are usually fun, but the big ones, tho thrilling, are usually spooky."

On August 1, they arrived on Lake Mead to be greeted by Doris in a motorboat and, later, a Nevada congressman, news reporters and film crews.

After the 1938 expedition and the publicity it received, Nevills gained more paying customers, although he and Doris struggled to become financially secure. In 1940, Norm and Doris led a trip from Green River, Wyoming, to Lake Mead. A young man from Arizona named Barry Goldwater accompanied them part of the way.

Others began to realize the business potential in river running, and by the mid-1940s, Nevills had several competitors. Around that time, he took flying lessons and purchased his first Piper Cub, which he flew all over the Four Corners region. On September 19, 1949, he and Doris took off from Norm's small airstrip at Mexican Hat, headed for Grand Junction. The engine sputtered and quit, and the plane slammed into a rock wall at the end of the strip. Doris and Norm were killed in the fiery crash, leaving behind two daughters.

But Norman Nevills's legacy lives on. The company he founded continued after his death and was eventually taken over by his daughter Joan and her husband, Gaylord Staveley. It still operates out of Flagstaff, Arizona, as Canyoneers. Additionally, numerous boatmen could trace their training back to either Nevills or people who learned from him. And in the twenty-first century, thousands of people each year pay commercial outfitters to take them on trips down the rivers of the Colorado Plateau. Some, no doubt, are young couples on their honeymoons.

31

EARLY CULTURES REVISITED

(Twenty-First Century)

In the early part of the twenty-first century, people travel the Colorado Plateau in ever-greater numbers than in previous eras. What were once obstacles to travel are now attractions. Isolation and stark beauty, deep river gorges and hard-to-reach canyons speak to people wanting a break from urban life. Along with the physical attraction is a growing curiosity about the people who lived here before.

Consequently, there is a keen interest in visiting rock art sites. Museums, schools, archaeology groups, government entities and private businesses conduct trips to remote locations on the Plateau, where some of the best rock art in the world has been preserved on remote cliff faces.

In the right locations, one can view the works of multiple ancient artists who lived thousands of years apart. Barrier Canyon–style drawings—which are named after a location in Canyonlands National Park in the heart of the Colorado Plateau—may be three thousand years old. They are sometimes found next to Fremont Indian drawings that date back a millennium or more. And next to them may be depictions of people on horseback, which were drawn by Utes, Navajos or others after the first contact with Europeans. Additionally, within the same area, one may find drawings by Ancestral Puebloans, also known as Anasazi, who built the famous rock structures of Mesa Verde National Park, the giant buildings of Chaco Culture National Historical Park and much more.

Many books offer information about rock art and what purpose the long-preserved drawings may have served. Museums, federal land management

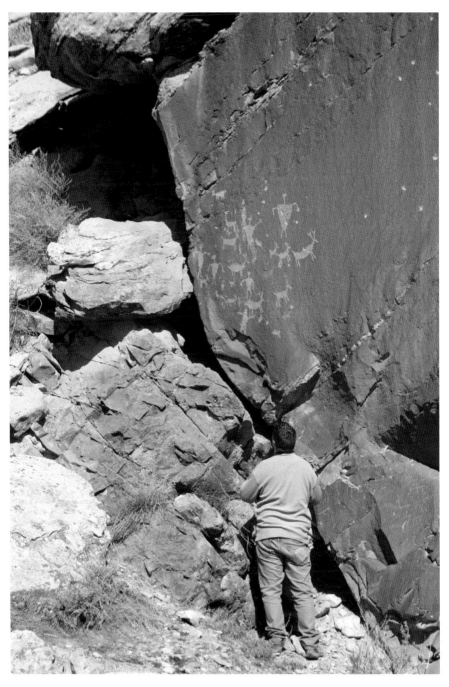

A visitor examines Fremont-style rock art on Bureau of Land Management property in Utah. *Photo by the author.*

agencies and academics are also increasingly turning to modern-day descendants of ancient residents—to Utes, Paiutes, Navajos, Hopis, Zunis and Apaches—for more insight into what the drawings mean, how the people who created them lived and how best to protect these sites.

Americans have long demonstrated a desire to preserve the magnificent landscapes of the West. The first national park on earth—Yellowstone—was established in Wyoming in 1872. Today, there is a greater concentration of national parks and monuments within the boundaries of the Colorado Plateau than any similar-sized place on the continent. In addition, the Plateau contains many other specially protected areas.

Within sixty miles of my home in western Colorado, there are three National Conservation Areas on lands overseen by the U.S. Bureau of Land Management: Gunnison Gorge NCA, Dominguez-Escalante NCA and McInnis Canyons NCA. Typical of the Colorado Plateau, they all have spectacular land forms and impressive vistas. And they are all cut by great rivers. Equally important, all have stunning rock art, as well as structures and other features that were created by native people who lived here long ago.

There has been a gradual change in people's attitudes toward the ancient inhabitants of the Colorado Plateau and the artifacts they left behind. Once, such artifacts were seen as treasures to be gathered and sold for profit or hidden in museums and private collections. Even rock art on hard-to-access cliff faces was occasionally chipped out and removed. These days, the prevailing ethic is to leave artifacts where they are found, to look at but not touch the ancient drawings, to be curious about such cultural remains but also respectful of what they mean to native people living today. Because of its dry climate and geographical isolation, the Plateau is uniquely suited to preserving evidence of early inhabitants.

Although trappers, traders, Mormons and a few other Americans arrived earlier, the Colorado Plateau did not become part of the United States until 1848, at the end of the war with Mexico and the Treaty of Guadalupe Hidalgo. Since that time, there have been ongoing disputes over how these lands can best be used—for Indians or white settlers, ranchers or homesteaders, natural-resource extraction or preservation and recreation.

Disputes continue today. And in many cases, such as the designation of the Bears Ears National Monument in southeastern Utah in 2016, a large part of the debate involves how best to preserve and protect sites that offer evidence of previous inhabitants.

Those early inhabitants developed reverence for this rugged land and its life-giving resources, as is indicated in much of the rock art and is evident in modern Indian cultures.

The current interest in earlier cultures and our pioneer history is indicative of a modern reverence for the Colorado Plateau. While we work and play on the Plateau, it's important to consider those who preceded us and how they helped shape human activity in this spectacular region. This book tells just a few stories of those who came earlier, the obstacles they faced in attempting to live and travel on the Colorado Plateau and the tenacity they demonstrated in overcoming such obstacles.

BIBLIOGRAPHY

Chapter 1

Author interview and site visit with Glade Hadden, archaeologist (since retired), Uncompahgre Field Office, U.S. Bureau of Land Management, Montrose, Colorado, May 2016.

Science Daily. July 2012. https://www.sciencedaily.com/releases/2012/07/120712141916.htm.

Chapter 2

Author interview with Carl Conner and Richard Ott of Grand River Institute and Dominquez Archaeological Research Group, Grand Junction, February 2017.

Baker, Steven G. *Juan Rivera's Colorado, 1765*. Lake City, CO: Western Reflections Publishing Company, 2015.

Bolton, Herbert E. *Pageant in the Wilderness: The Story of the Escalante Expedition to the Interior Basin, 1776*. Salt Lake City: Utah State Historical Society, 1972.

Cole, Sally. *Legacy on Stone: Rock Art of the Colorado Plateau and Four Corners Region*. Boulder, CO: Johnson Books, 1990.

Lekson, Stephen H. *The Chaco Meridian*. Walnut, CA: Altamira Press, 1999.

Chapter 3

Becker, Cynthia, and David P. Smith. *Chipeta, Queen of the Utes*. Montrose, CO: Western Reflections Publishing Company, 2003.

Dawson, Thomas F., and F.J.V. Skiff. *The Ute War: A History of the White River Massacre and the Privations and Hardships of the Captive White Women among the Hostiles on Grand River.* Denver, CO: Tribune Publishing House, 1879. From microfilm available and Colorado Mesa University, Grand Junction, Colorado Western Americana Series, Yale University, 1975.

Heap, Gwin Harris. *Central Route to the Pacific from the Valley of the Mississippi to California: Journal of the Expedition of E.F. Beale, Superintendent of Indian Affairs in California, and Gwin Harris Heap, from Missouri to California in 1853.* Philadelphia, PA: Lippincott, Grambo and Company, 1854.

Petite, Jan. *Utes, the Mountain People*. Boulder, CO: Johnson Printing, 2005.

Roe, Frank Gilbert. *The Indian and the Horse*. Norman: University of Oklahoma Press, 1955.

Silbernagel, Robert, *Troubled Trails: The Meeker Affair and the Expulsion of Utes from Colorado*. Salt Lake City: University of Utah Press, 2011.

Simmons, Virginia McConnell. *The Ute Indians of Utah, Colorado, and New Mexico*. Boulder: University Press of Colorado, 2000.

Chapter 4

Author interview with Curtis Martin, lead archaeologist, the Colorado Wickiup Project, April 2013 and May 2016.

Martin, Curtis. *Ephemeral Bounty: Wickiups, Trade Goods, and the Final Years of the Autonomous Ute*. Salt Lake City: University of Utah Press, 2016.

Chapter 5

Author interview with Steven G. Baker, Centuries Research Inc., Montrose, Colorado, October 2015 and January 2016.

Baker, Steven G. *Juan Rivera's Colorado, 1765*. Lake City, CO: Western Reflections Publishing Company, 2015.

Colorado Encyclopedia. "Juan Antonio Maria de Rivera." https://coloradoencyclopedia.org/article/juan-antonio-mar%C3%ADa-de-rivera.

Chapter 6

Author interview with Dave Bailey, curator of History, the Museums of Western Colorado, November and December 2016.

Baker, Steven G. *Juan Rivera's Colorado, 1765*. Lake City, CO: Western Reflections Publishing Company, 2015.

Bolton, Herbert E. *Pageant in the Wilderness: The Story of the Escalante Expedition to the Interior Basin, 1776*. Salt Lake City: Utah State Historical Society, 1972.

Domínguez, Fray Francisco Atanasio. *The Missions of New Mexico, 1776*. Albuquerque: University of New Mexico Press, 1975.

National Park Service. "Dominguez-Escalante National Historic Trail." November 1980. http://npshistory.com/publications/transportation/dominguez-escalante-nht.pdf.

Chapter 7

Barton, John D. "Antoine Robidoux—Buckskin Entrepreneur." *Outlaw Trail Journal* 3, 4 (Summer/Fall 1993 and Winter/Spring 1994) http://ocw.usu.edu/History/History_of_Utah/Utah_History__Antoine_Robidoux.pdf.

DeVoto, Bernard. *Across the Wide Missouri*. Boston, MA: Houghton Mifflin, 1947.

Reyher, Ken. *Antoine Robidoux and Fort Uncompahgre*. Montrose, CO: Western Reflections Publishing, 1998.

Sage, Rufus B. *Rocky Mountain Life, or Startling Scenes and Perilous Adventures in the Far West During an Expedition of Three Years*. Boston: Thayer and Eldridge, 1859.

Chapter 8

Author interview with Jon Horn, senior principal investigator, Alpine Archaeological Consultants, Montrose, Colorado, May 2015.

Brewerton, George Douglas. *Overland with Kit Carson: A Narrative of the Old Spanish Trail in '48*. New York: Coward-McCann, 1930.

Hafen, LeRoy R., and Ann W. Hafen. *The Old Spanish Trail*. Lincoln: University of Nebraska Press, 1993.

Kessler, Ron. *Old Spanish Trail North Branch, and Its Travelers*. Santa Fe, NM: Sunstone Press, 1998.

National Park Service, Old Spanish Trail. https://www.nps.gov/olsp/index.htm.

Old Spanish Trail Association. http://www.oldspanishtrail.org.

Chapter 9

Powell, John Wesley. *The Exploration of the Colorado River and Its Canyons*. New York: Penguin Books, 2003.

————. "Journals of John Wesley Powell, Jack Sumner and George Bradly." *Utah Historical Quarterly* 15 (1947).

Stegner, Wallace. *Beyond the Hundredth Meridian: John Wesley Powell and the Second Opening of the West*. New York: Penguin Books, 1992.

————. "Jack Sumner and John Wesley Powell." *Colorado Magazine* (January 1949).

Chapter 10

"Flume Work of the Montrose Placer Mining Company." *The Engineering and Mining Journal, Volume XLIX*, January to June 1890, May 17, 1890. New York: Scientific Publishing Company, 1890.

Hanging Flume. "Hanging Flume on the Unaweep-Tabeguache Scenic & Historic Byway." http://hangingflume.org.

Interpretive Association of Western Colorado. "Hanging Flume Reconstruction Project." http://wcinterp.com/portfolio/hanging-flume-reconstruction-project.

Pfertsh, Jack. "History and Background of the Hanging Flume." *Alpine Archaeological Consultants* (2005).

U.S. Geological Survey. "Mining Water Use." http://www.water.usgs.gov.

Chapter 11

Emory County Progress. "Big Steamboat Scheme." November 1901.

Manly, William Lewis. *Death Valley in '49*. San Jose, CA: Pacific Tree and Vine Company, 1894.

Powell, John Wesley. *The Exploration of the Colorado River and Its Canyons*. New York: Penguin Books, 2003.

Salt Lake Telegram. "Steamboat Wrecked on the Grand River," May 23, 1902.

Staveley, Gaylord. *The Rapids and the Roar: A Boating History of the Colorado River and Grand Canyon*. Flagstaff, AZ: Fretwater Press, 2015.

Chapter 12

Bardell, Paul H., Jr. *Peaches and Politics in Palisade, Colorado: A Town Shaped by its Canals, Roads and Bridges*. West Conshohocken, PA: Infinity Publishing, 2009.

Fedarko, Kevin. *The Emerald Mile: The Epic Story of the Fastest Ride in History Through the Heart of the Grand Canyon*. New York: Scribner, 2013.

The History of Irrigation in Palisade and East Orchard Mesa, Colorado. Palisade, CO: Palisade Historical Society, 2015.

Chapter 13

Aitchison, Stewart. *A Guide to Southern Utah's Hole-in-the-Rock Trail*. Salt Lake City: University of Utah Press, 2005.

Author interview with Vern Howell, Loma, Colorado, March 15, 2017.

Hole in the Rock Remembered, http://trekholeintherock.blogspot.com.

Lavender, David. *One Man's West*. Lincoln: University of Nebraska Press, 2007.

Miller, David. *Hole in the Rock: An Epic in the Colonization of the Great American West*. Salt Lake City: University of Utah Press, 1966.

Chapter 14

Daily Sentinel, 1902, 1909, 1913.

Gormley, Pat. *Charles R. Sieber of Glade Park and Piñon Mesa Colorado*. Self-published, 2002.

Chapter 15

Daily Sentinel. "Sheep Army," January 21, 1908.

U.S. Tariff Commission. "The Wool-Growing Industry, 1921." Washington, D.C.: Government Printing Office, 1921.

Chapter 16

Delta County Independent. "Escalante Canyon Dweller Learns Secret Indian Art of Fashioning Flint Arrowheads; Now Lost to Man," May 8, 1958.

Pfertsh, Jack. "History and Background of the Hanging Flume." *Alpine Archaeological Consultants* (2005).

Rockwell, Wilson. *Uncompahgre Country.* Ouray, CO: Western Reflection, 1999.

Chapter 17

Chenoweth, William. "Geology and Production History of the Mitchell Butte Uranium-Vanadium Mine." *Arizona Geological Survey* (January 1995).

Knipmeyer, James H. *Cass Hite: The Life of an Old Prospector.* Salt Lake City: University of Utah Press, 2016.

———. *Joe Duckett: The Hermit of Montezuma Canyon.* Chula Vista, CA: Aventine Press, 2011.

McPherson, Robert, "Navajos, Mormons and Henry L., Mitchell: Cauldron of Conflict on the San Juan," *Utah Historical Quarterly* 55, no. 1 (Winter 1987). http://content.lib.utah.edu/u?/USHSArchPub,7513.

Chapter 18

Butler, B.S. "Notes on the Unaweep Copper District, Colorado." *U.S. Geological Survey*, Washington, D.C., 1914. https://pubs.usgs.gov/bul/0580b/report.pdf.

Carroll, Fred. *Sixteenth Biennial Report Issued by the Bureau of Mines of the State of Colorado for the Years 1917 and 1918.* Denver, CO: Rames Brothers, 1919.

Daily Sentinel. 1898.

Lee, Harry A. *Report of the State Bureau of Mines, Colorado, for the Year 1897*. Denver, CO: N.p., 1897.

Moores, Jean. *Gateway/Unaweep Canyon at Some Point in Time*. Decorah, IA: Anundsen Publishing Company, 2000.

Salt Lake City Herald. "New Copper Camp." May 1898.

Chapter 19

Author interview with James H. Knipmeyer, Museums of Western Colorado, August 2016.

Knipmeyer, James H. *Cass Hite: The Life of an Old Prospector*. Salt Lake City: University of Utah Press, 2016.

Chapter 20

Bird, Allan G. *Bordellos of Blair Street: The Story of Silverton, Colorado's Notorious Red Light District*. Pierson, MI: Advertising, Publications & Consultants, 1993.

MacKell, Jan. *Brothels, Bordellos & Bad Girls: Prostitution in Colorado, 1860–1930*. Albuquerque: University of New Mexico Press, 2007.

Chapter 21

Museum of Moab, Moab, Utah. "Uranium Revisited." *Canyon Legacy* 75 (Winter 2016).

National Mining Hall of Fame and Museum. "Steen, Charles Augustus (Charlie)." https://www.mininghalloffame.org/inductee/steen.

Newell, Maxine. *Charlie Steen's Mi Vida*. Moab, UT: Canyonlands Advertising, 1992.

Chapter 22

Baker, Pearl. *The Wild Bunch at Robbers Roost*. New York: Abelard-Schuman, 1971.

Betenson, W.J. *Butch Cassidy, My Uncle: A Family Portrait*. Glendo, WY: High Plains Press, 2014.

McCarty, Tom. *History of Tom McCarty: His Latest Exploits as Related by Himself.* Typewritten copy on file at Delta County Historical Society, Delta, Colorado.

Pocock, Roger. "Canada to Mexico: A Ride Across the Great American Desert," *Lloyd's Weekly Newspaper* (London, UK), July 15, 1900, to September 16, 1900. Online at the Long Riders' Guild, http://www.thelongridersguild.com/pocock-lloyds.htm.

San Francisco Call. "Rounding Up Outlaws in the Colorado Basin," April 3, 1898.

Warner, Matt (as told to Murray E. King). *The Last of the Bandit Riders.* New York: Bonanza Books, 1960.

Chapter 23

Betenson, W.J. *Butch Cassidy, My Uncle: A Family Portrait.* Glendo, WY: High Plains Press, 2014.

McCarty, Tom. *History of Tom McCarty: His Latest Exploits as Related by Himself.* Typewritten copy on file at Delta County Historical Society, Delta, Colorado.

Skovlin, Jon M., and Donna McDaniel. *In Pursuit of the McCartys.* Cove, OR: Reflections Publishing Company, 2001.

Warner, Matt (as told to Murray E. King). *The Last of the Bandit Riders.* New York: Bonanza Books, 1960.

Wetzel, James K. *Banks, Bullets & Bodies: A Failed Robbery in Delta, Colorado.* Delta, CO: self-published, 2014.

Chapter 24

Boren, Kerry Ross. "A Personal Interview with Josie Bassett." *Amber,* August 20, 2014, http://www.amberandchaos.net.

McClure, Grace. *The Bassett Women.* Athens, OH: Swallow Press, 1985.

Moffatt County Courier. "Craig Featured as Wild West Show." August 21, 1913.
————. "Mrs. Bernard Cleared." August 21, 1913.

Willis, Ann Bassett. "'Queen Ann' of Brown's Park: The Autobiography of Ann Bassett Willis." *Colorado Magazine* 29, no. 2 (April 1952).

Chapter 25

Bender, Henry E., Jr. *Uintah Railway: The Gilsonite Route*. Berkeley, CA: Howell-North Books, 1970.

Polley, Rodger, *Uintah Railway Pictorial*. Vol. 1, *Mack to Atchee*. Denver, CO: Sundance Publications, 1999.

Vernal Express, February 12, 1909.

Chapter 26

Author interview with Sonya Popelka, interpretive operations supervisor, Dinosaur National Monument, June 2015.

Douglass, G.E. *Speak to the Earth and It Will Teach You: The Life and Times of Earl Douglass, 1862–1931*. Self-published, 2009.

Chapter 27

Daily Sentinel, March 1914–April 1914.

Westgard, A.L. *Tales of a Pathfinder*. Washington, D.C.: Andrew B. Graham County, 1920.

Chapter 28

Driggs, Laurence La Tourette. *Arnold Adair with the English Aces*. Boston: Little, Brown & Company, 1922.

———. "Fighting Forest Fires from the Sky," *Outlook Magazine*, January 1921.

Encyclopedia Staff. "Driggs Mansion." *Colorado Encyclopedia*, last modified August 25, 2017, http://coloradoencyclopedia.org/article/driggs-mansion.

Gardner, Lester D. *Who's Who in American Aeronautics*. New York: Gardner, Moffat Company, 1922.

National Park Service. "Fire and Aviation Management: Operational Inventions & Developments." https://www.nps.gov/fire/wildland-fire/learning-center/fireside-chats/history-timeline/operational-inventions-and-developments.cfm.

Chapter 29

Author interviews with Anita Clark, October 2016, and George Decker, November 2013.

Burton, Doris Karren. *Blue Mountain Folks: Their Lives and Legends*. Vernal, UT: Uintah County Library, 2003.

"Kokopelli Legend and Lore," indigenouspeople.net/kokopelli.htm.

Miller, David. *Hole in the Rock: An Epic in the Colonization of the Great American West*. Salt Lake City: University of Utah Press, 1966.

Moores, Jean. *Gateway/Unaweep Canyon at Some Point in Time*. Decorah, IA: Anundsen Publishing Company, 2000.

Southern Ute. "Bear Dance." https://www.southernute-nsn.gov/culture/bear-dance.

Chapter 30

Daily Sentinel. June 21–August 21, 1938.

San Juan Record. "Colorado River Expedition Starts Hazardous Trip," June 23, 1938.

———. "Nevills Expedition Arrives Lake Mead," August 4, 1938.

———. "Nevills Party Arrives Safely at Lee's Ferry," July 14, 1938.

Staveley, Gaylord. "The Canyoneers Story: From Nevills to Nowadays," Canyoneers, http://canyoneers.com/about-us/canyoneers-story.

———. *The Rapids and the Roar: A Boating History of the Colorado River and Grand Canyon*. Flagstaff, AZ: Fretwater Press, 2015.

Webb, Roy. *High, Wide, and Handsome: The River Journals of Norman D. Nevills*. Logan: Utah State University Press, 2005.

Chapter 31

Author interviews with Zebulon Miracle, curator at Gateway Canyons Resort, June 2017.

Cole, Sally. *Legacy on Stone: Rock Art of the Colorado Plateau and Four Corners Region*. Boulder, CO: Johnson Books, 1990.

INDEX

ABOUT THE AUTHOR

Robert Silbernagel was the editorial page editor for the *Daily Sentinel* newspaper in Grand Junction for nineteen years. Now retired, he continues to write a regional history column for the *Sentinel*. Mr. Silbernagel is the author of the book *Troubled Trails: The Meeker Affair and the Expulsion of Utes from Colorado*, published by the University of Utah Press in 2011. He also wrote *Dinosaur Stalkers: Tracking Dinosaur Discoveries of Western Colorado and Eastern Utah*, published by Dinamation International, the Bureau of Land Management and the Museums of Western Colorado in 1996. Mr. Silbernagel has written history articles for periodicals, including the *Wisconsin Magazine of History* and *Colorado Heritage*. He and his wife, Judy, live near Palisade, Colorado.